HOUSEPLANTS AND HOT SAUCE

A SEEK-AND-FIND BOOK FOR GROWN-UPS

BY SALLY NIXON

CHRONICLE BOOKS

SAN FRANCISCO

"So, what'd you do this weekend, Jane?"

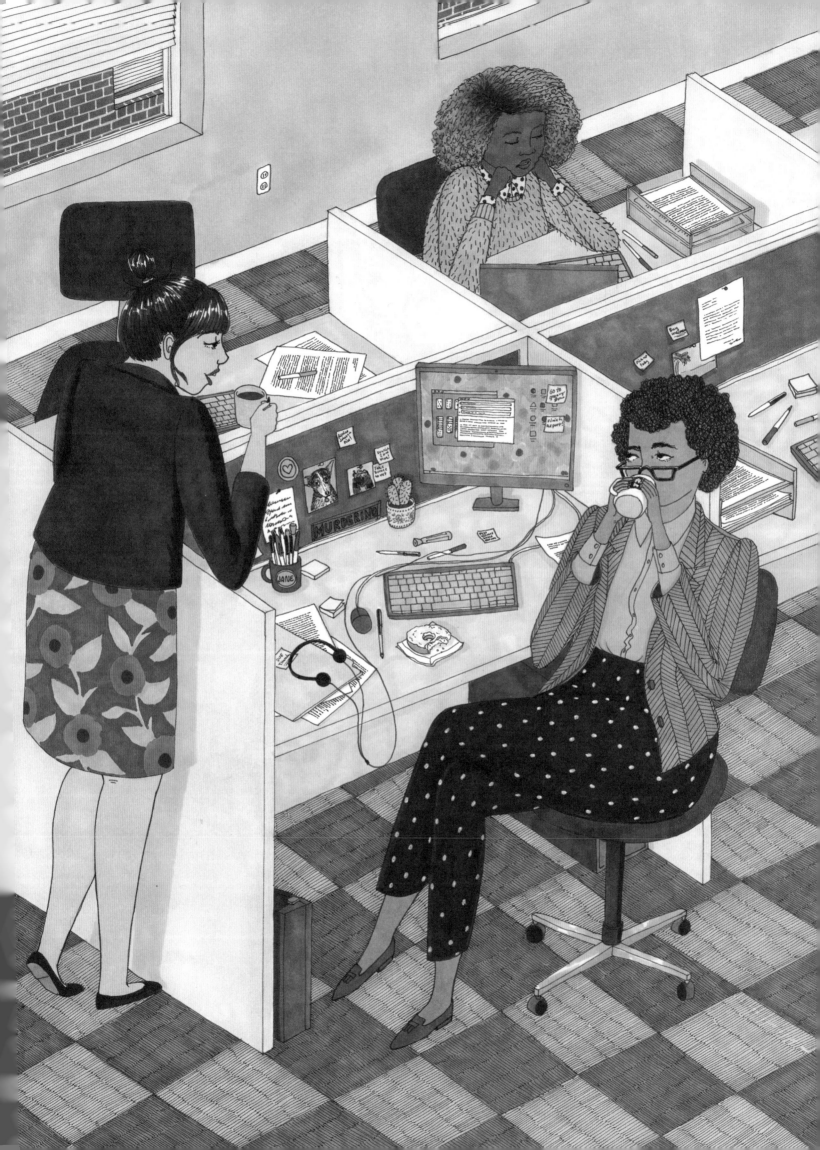

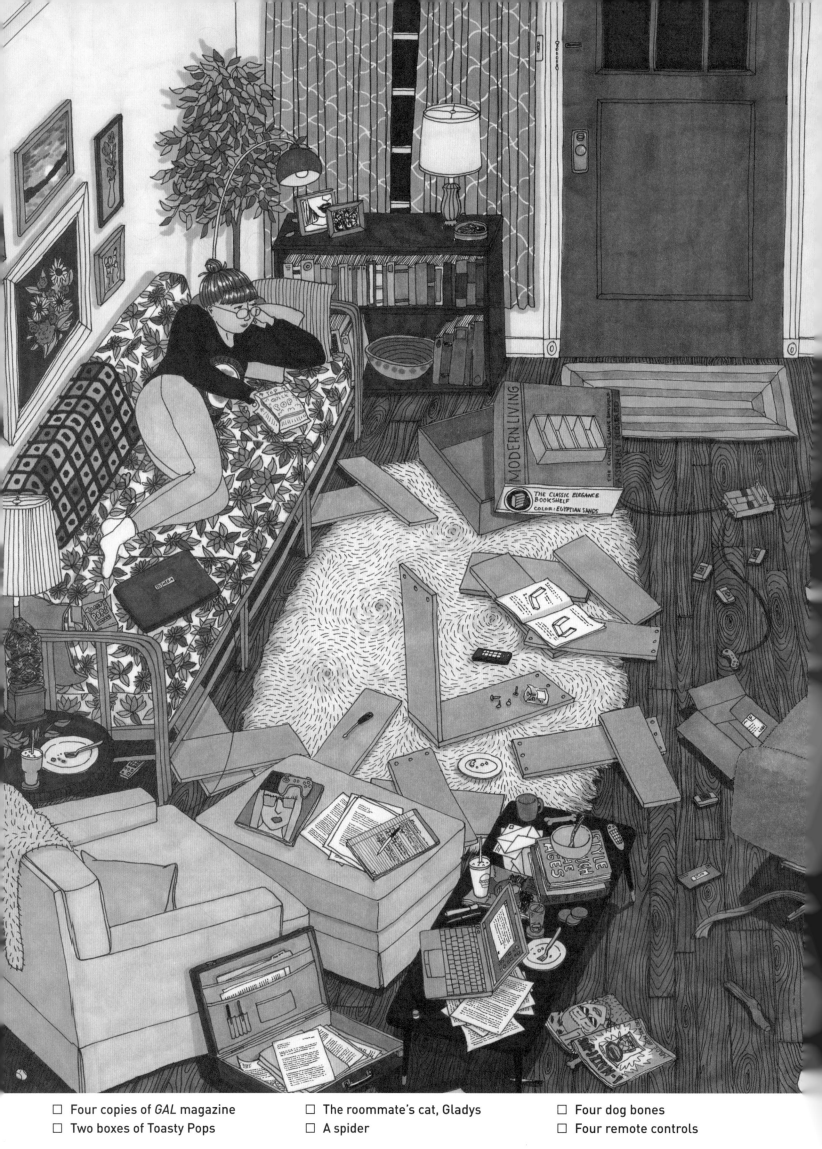

☐ Four copies of *GAL* magazine
☐ Two boxes of Toasty Pops
☐ The roommate's cat, Gladys
☐ A spider
☐ Four dog bones
☐ Four remote controls

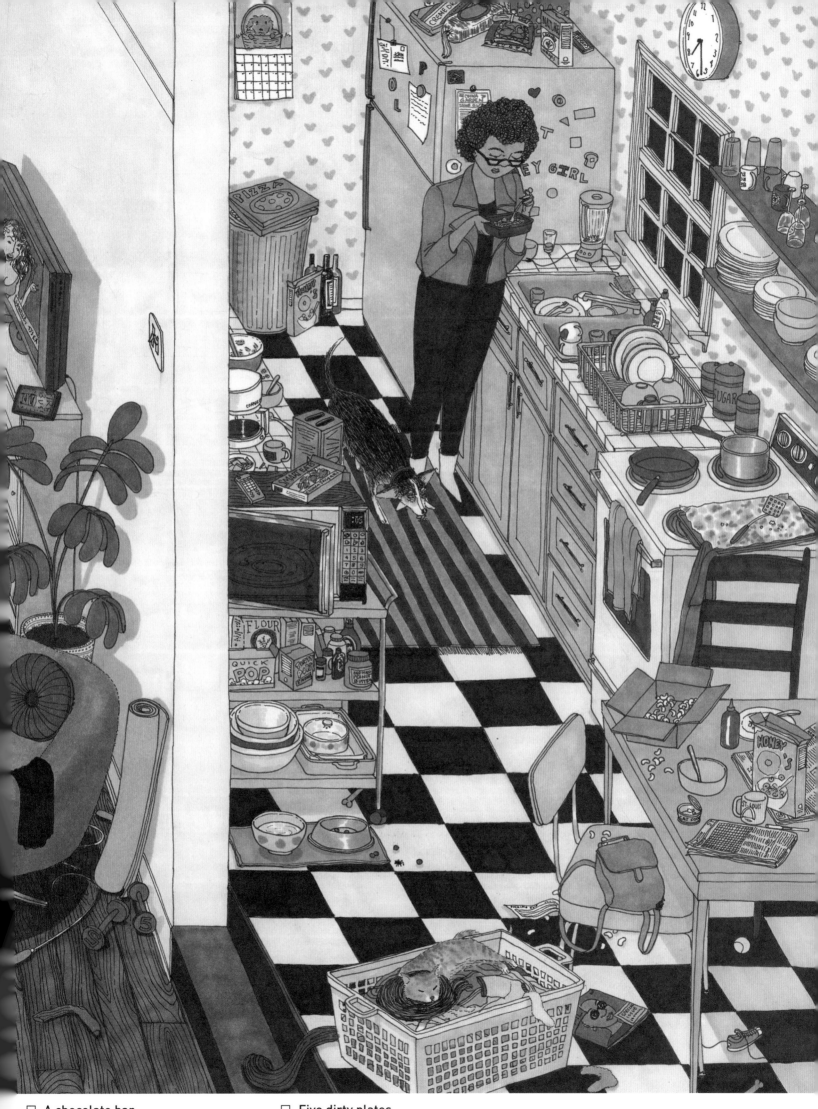

☐ A chocolate bar

☐ A tin of cat food

☐ Five dirty plates

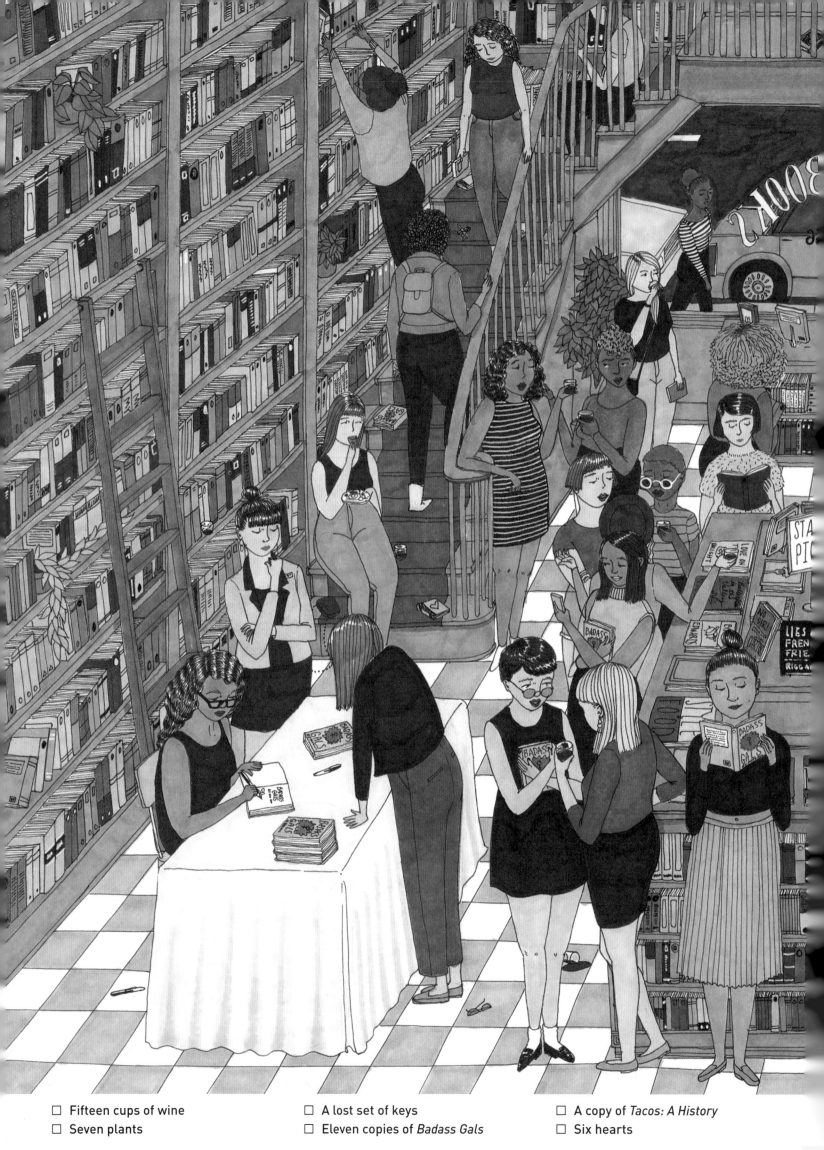

☐ Fifteen cups of wine ☐ A lost set of keys ☐ A copy of *Tacos: A History*

☐ Seven plants ☐ Eleven copies of *Badass Gals* ☐ Six hearts

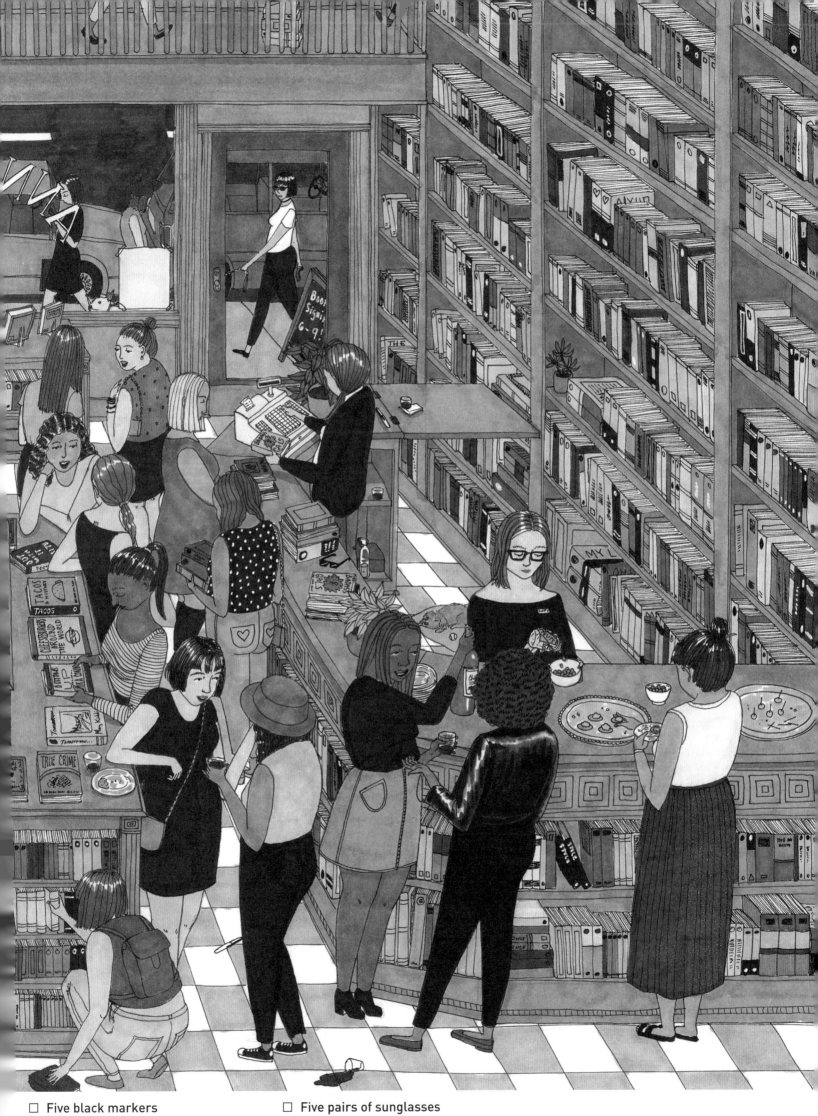

☐ Five black markers ☐ Five pairs of sunglasses
☐ A jar of nuts ☐ Two dogs

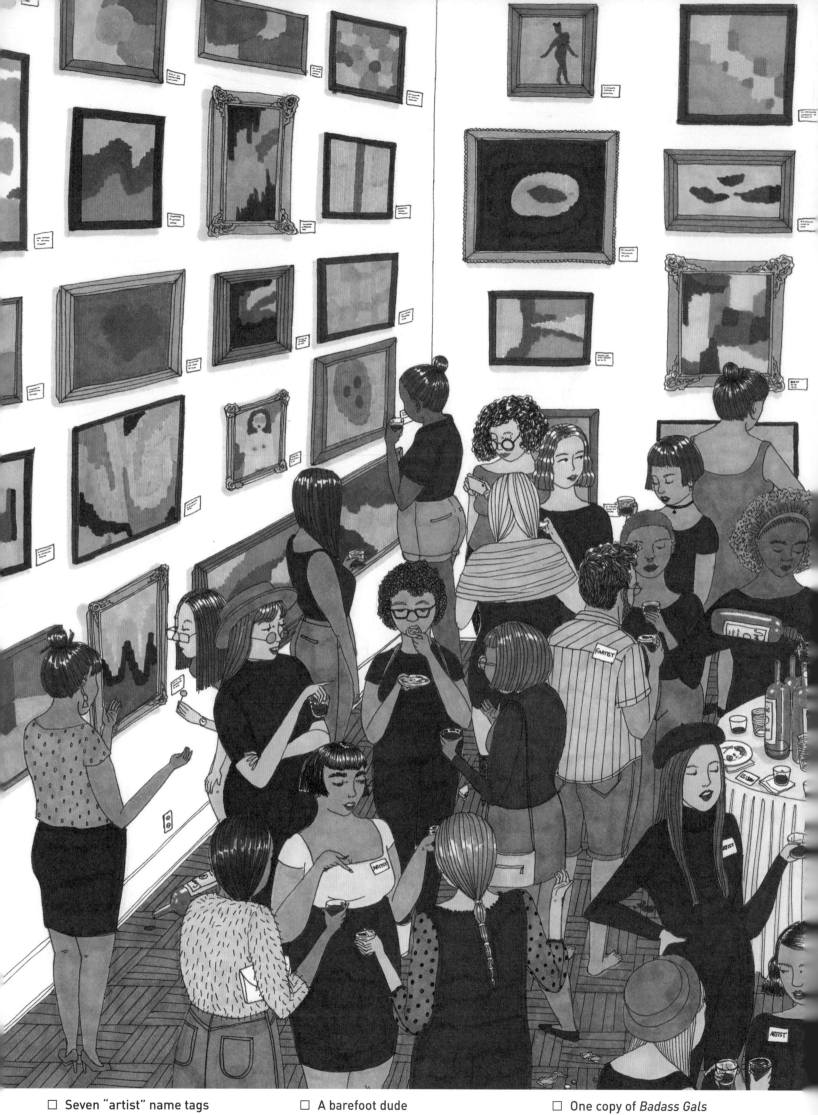

☐ Seven "artist" name tags
☐ Two nudes
☐ A barefoot dude
☐ A pair of cat ears
☐ One copy of *Badass Gals*
☐ A dollar

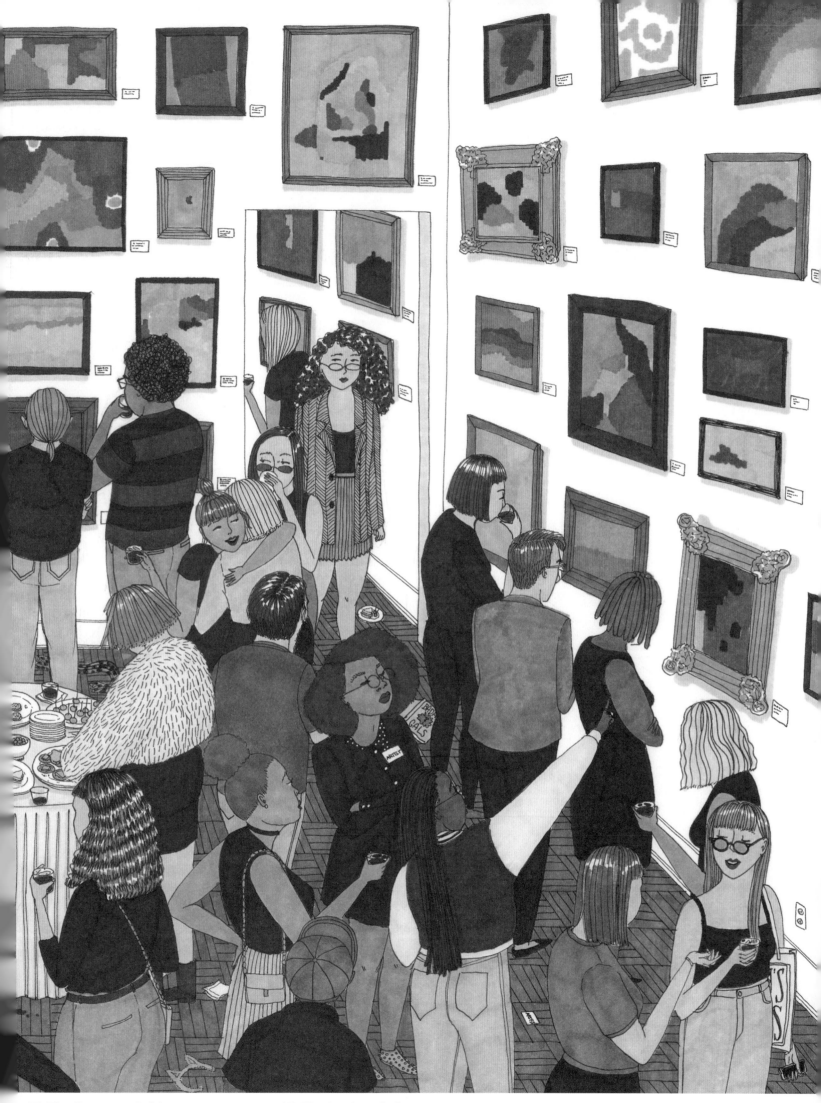

☐ Five finger sandwiches ☐ Five bottles of wine

☐ A dog

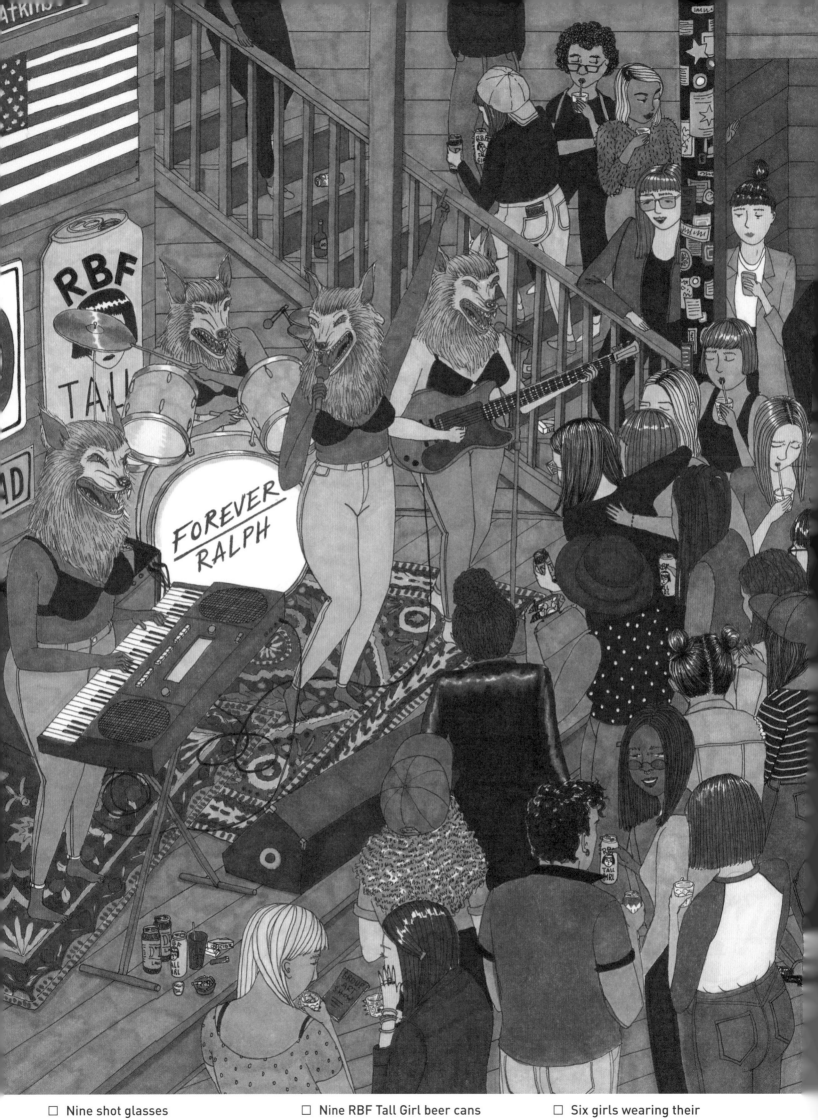

☐ Nine shot glasses
☐ An order of fries

☐ Nine RBF Tall Girl beer cans
☐ Six packs of Cigz

☐ Six girls wearing their sunglasses at night

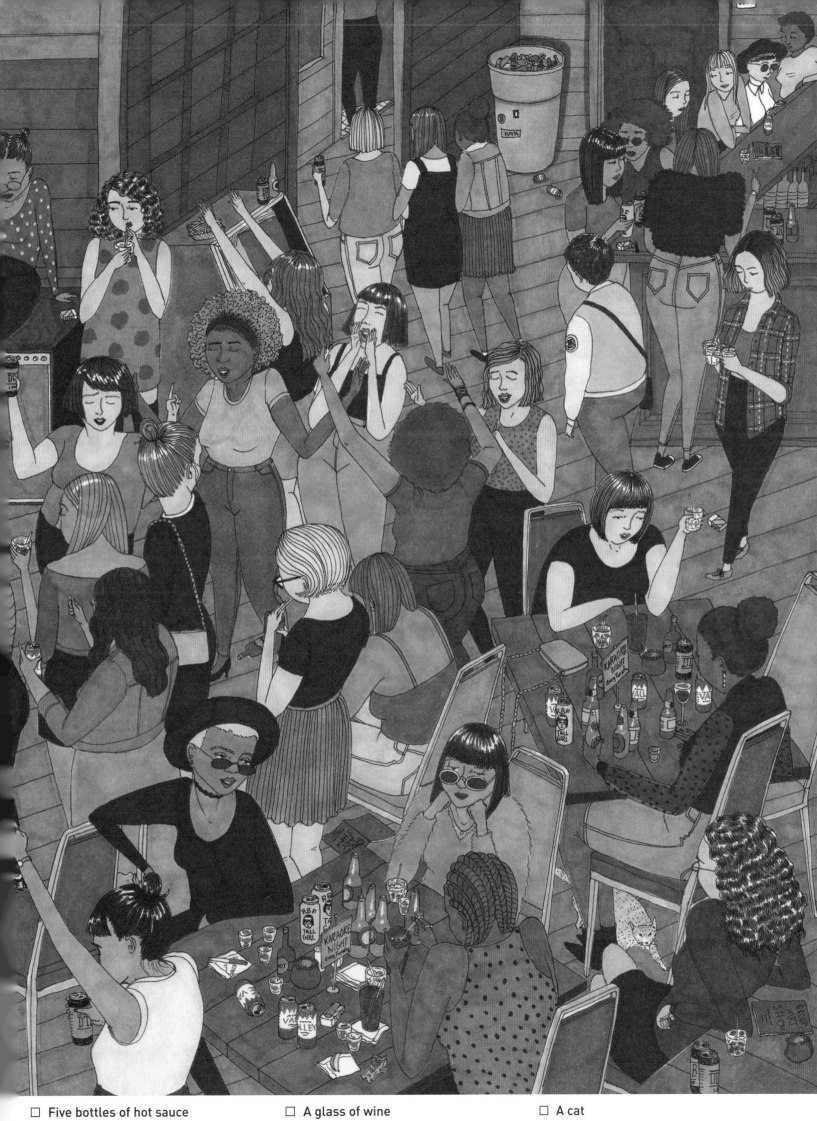

☐ Five bottles of hot sauce
☐ Five programs from the art show
☐ A glass of wine
☐ Six hats
☐ A cat

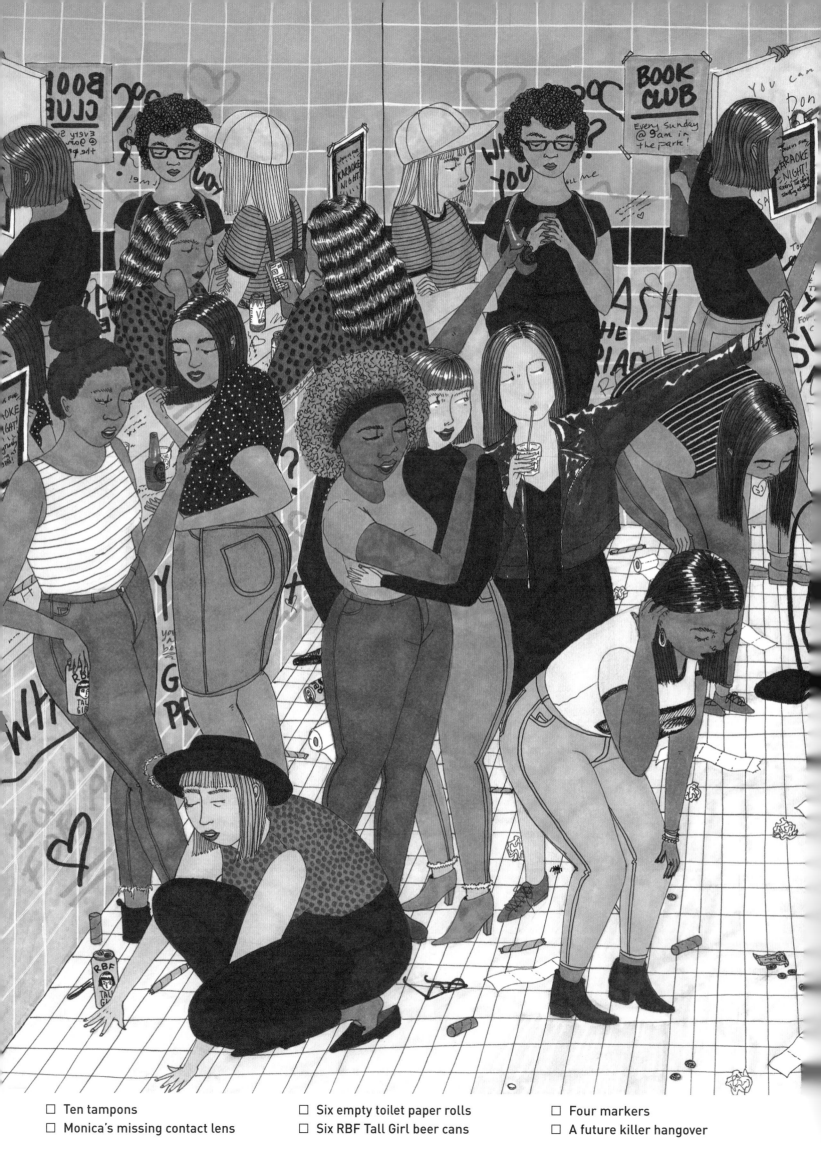

☐ Ten tampons
☐ Monica's missing contact lens
☐ Six empty toilet paper rolls
☐ Six RBF Tall Girl beer cans
☐ Four markers
☐ A future killer hangover

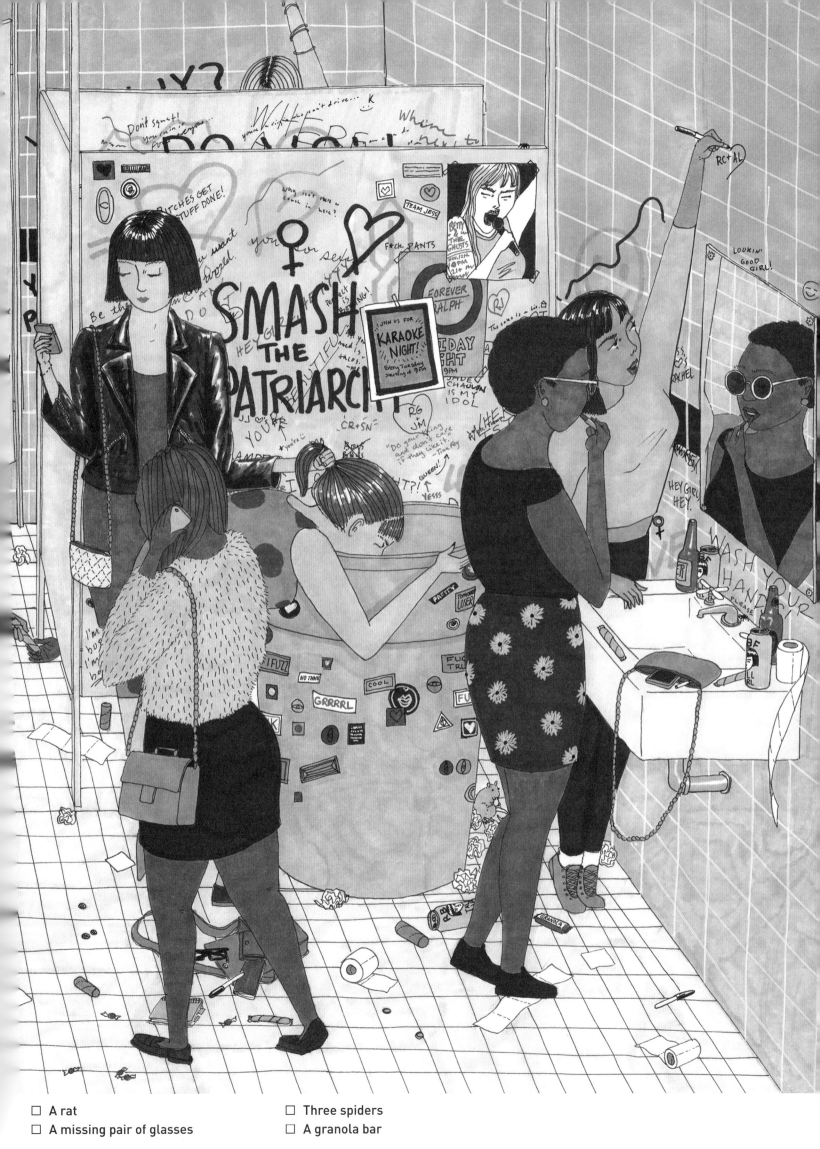

☐ A rat
☐ A missing pair of glasses
☐ Three spiders
☐ A granola bar

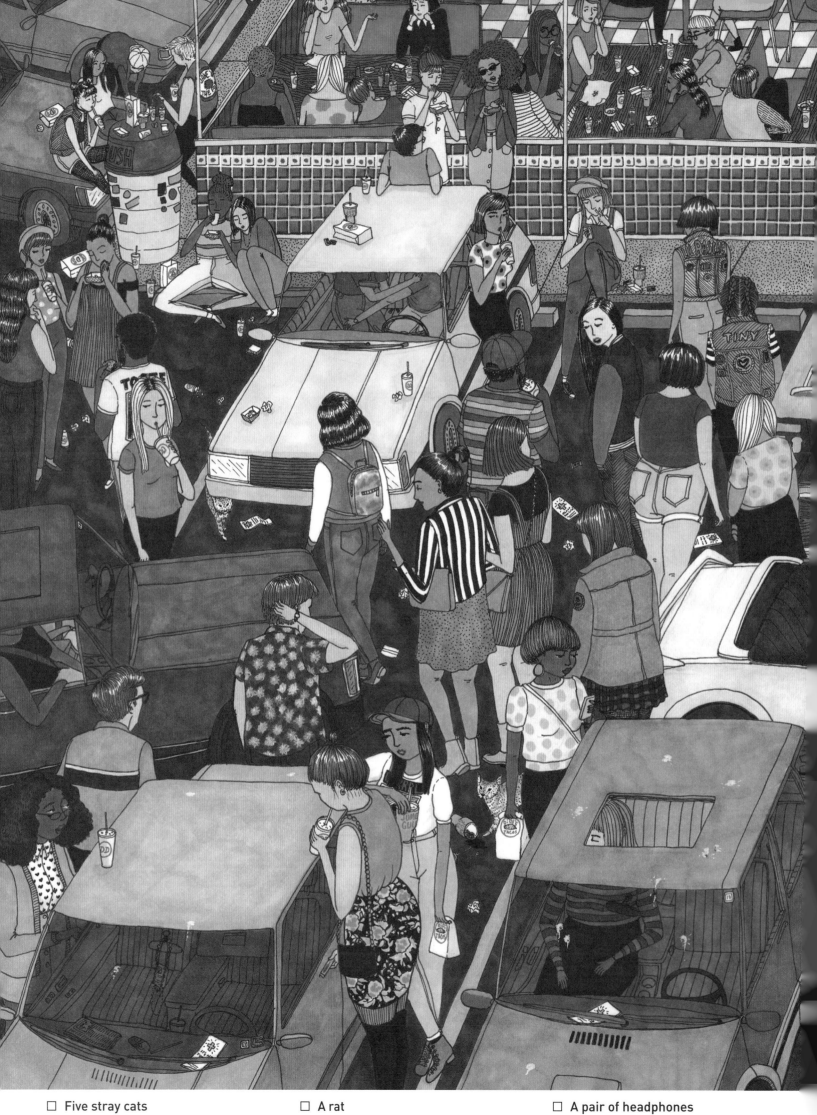

☐ Five stray cats
☐ Nine Jumbo Gulps

☐ A rat
☐ Nine hot sauce packets

☐ A pair of headphones
☐ Nine religious pamphlets

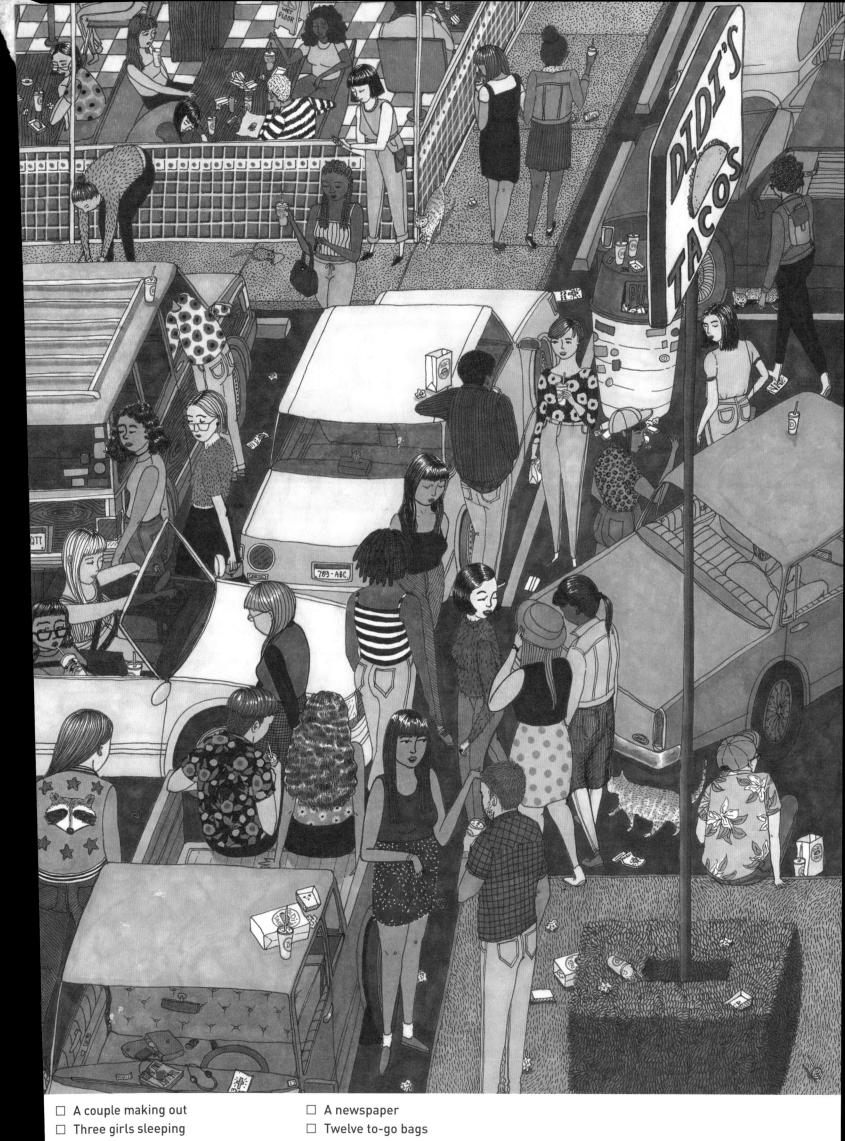

- ☐ A couple making out
- ☐ Three girls sleeping
- ☐ A newspaper
- ☐ Twelve to-go bags

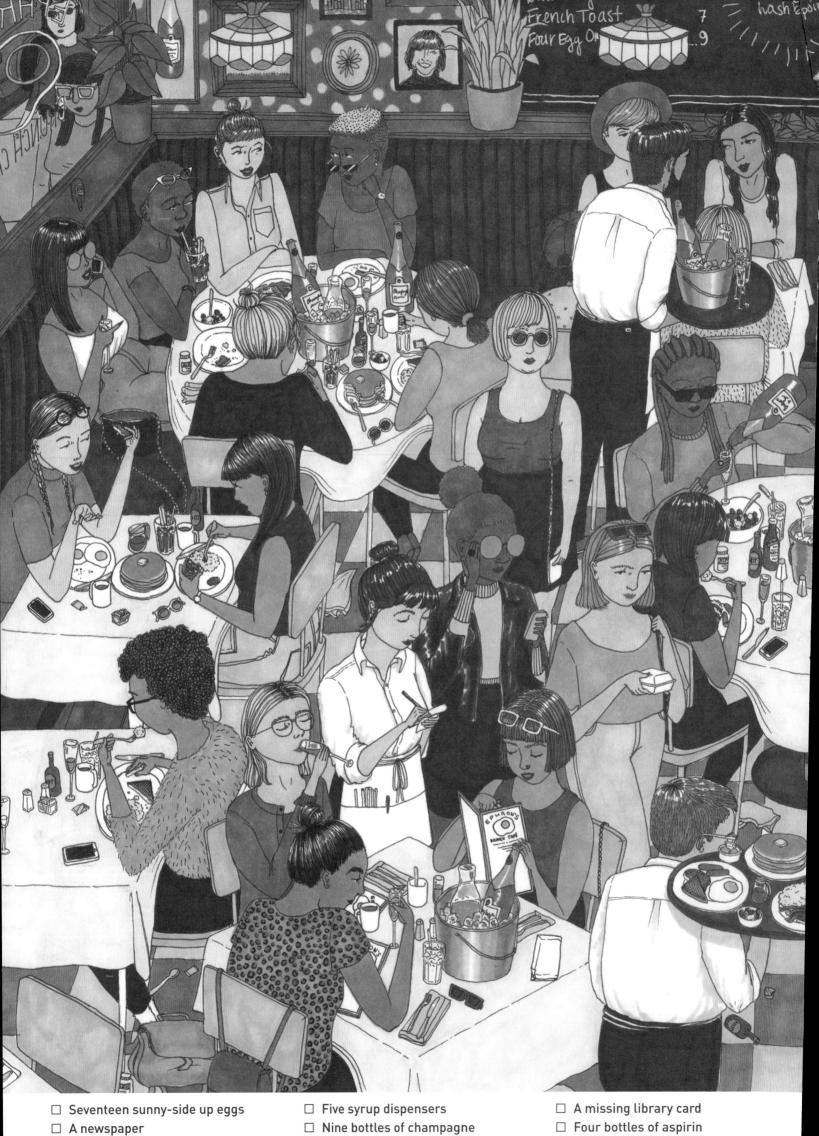

☐ Seventeen sunny-side up eggs
☐ A newspaper

☐ Five syrup dispensers
☐ Nine bottles of champagne

☐ A missing library card
☐ Four bottles of aspirin

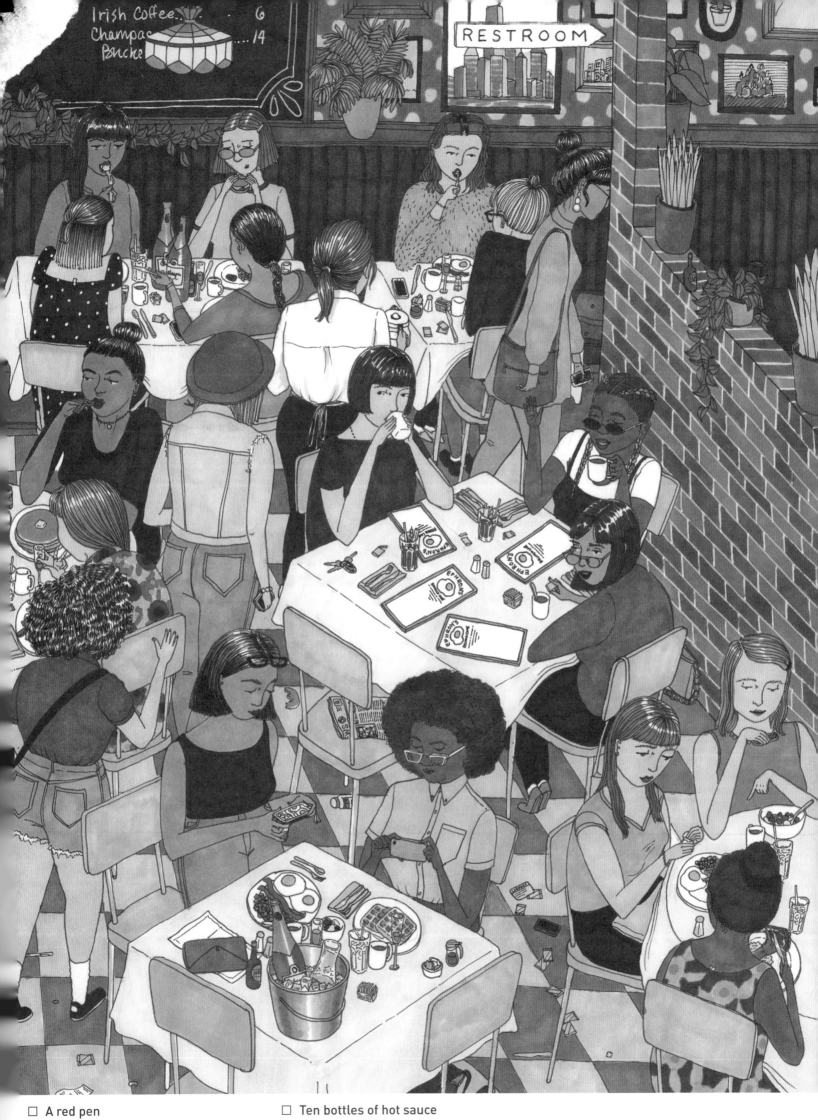

☐ A red pen
☐ Five Bloody Marys
☐ Ten bottles of hot sauce
☐ Ten plants

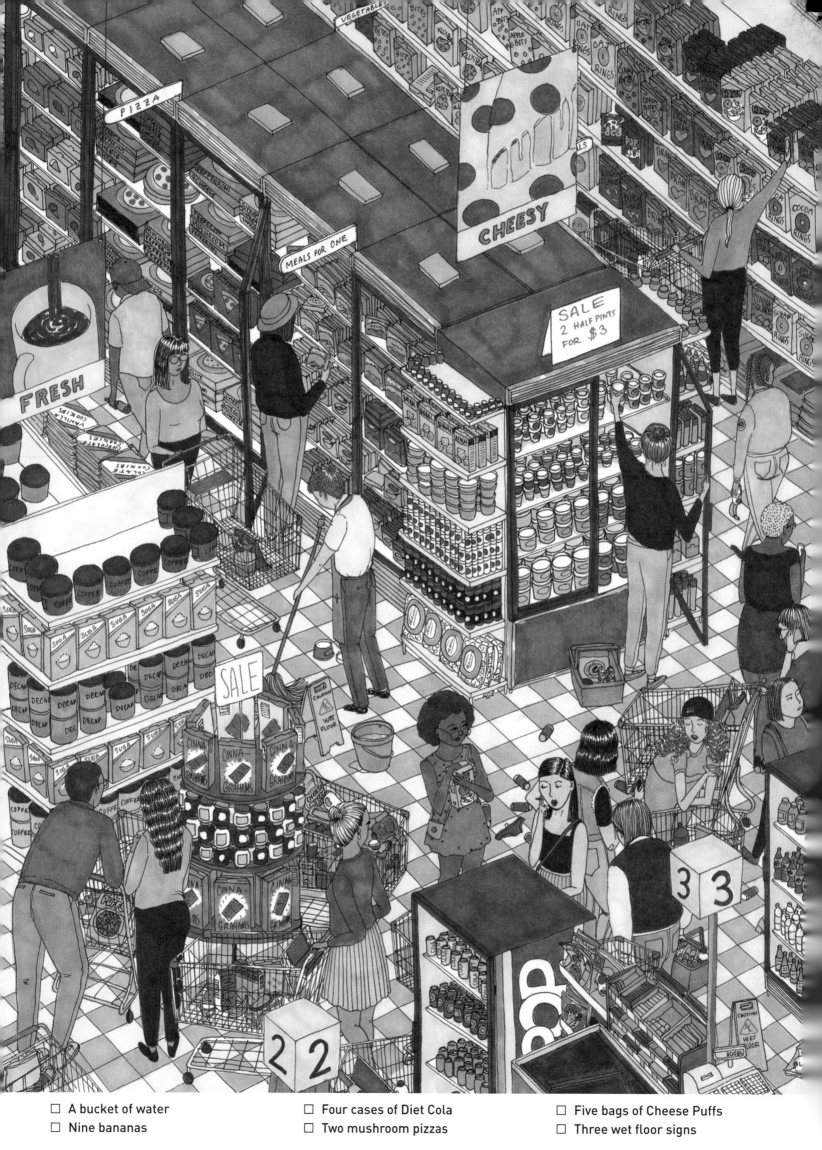

- ☐ A bucket of water
- ☐ Nine bananas
- ☐ Four cases of Diet Cola
- ☐ Two mushroom pizzas
- ☐ Five bags of Cheese Puffs
- ☐ Three wet floor signs

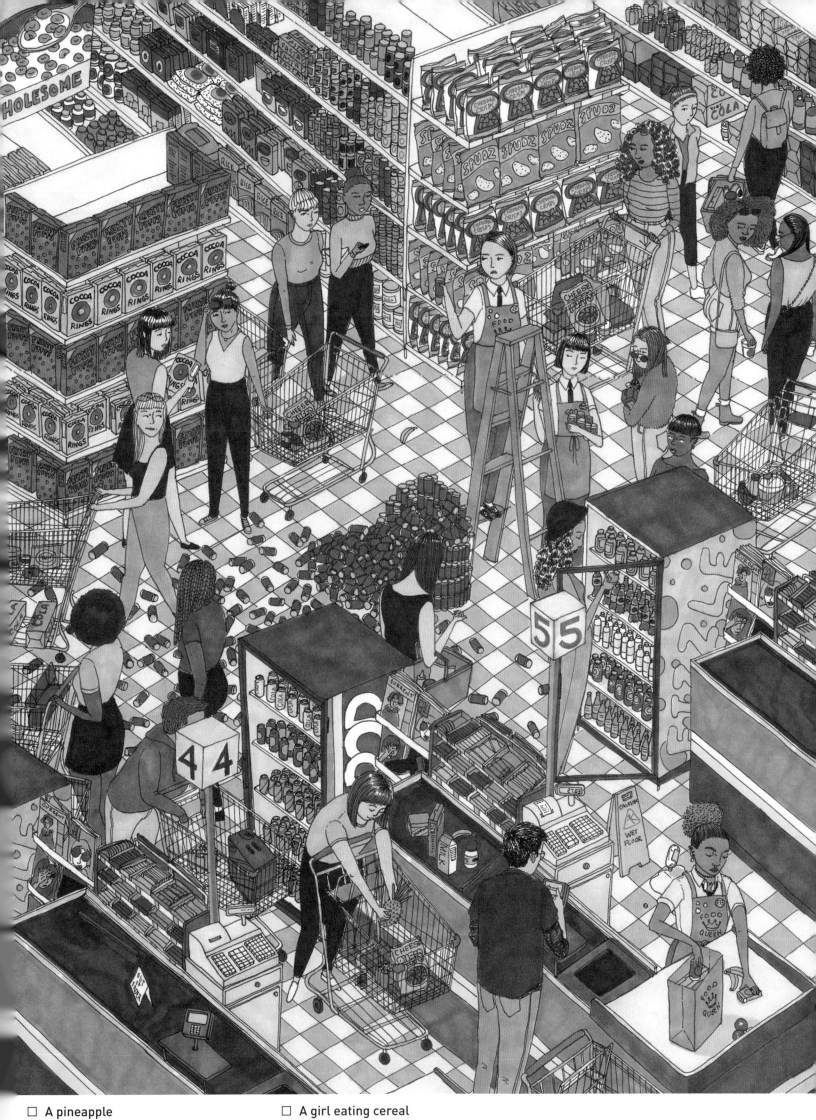

☐ A pineapple
☐ A pair of underwear
☐ A girl eating cereal
☐ A to-go cup of coffee

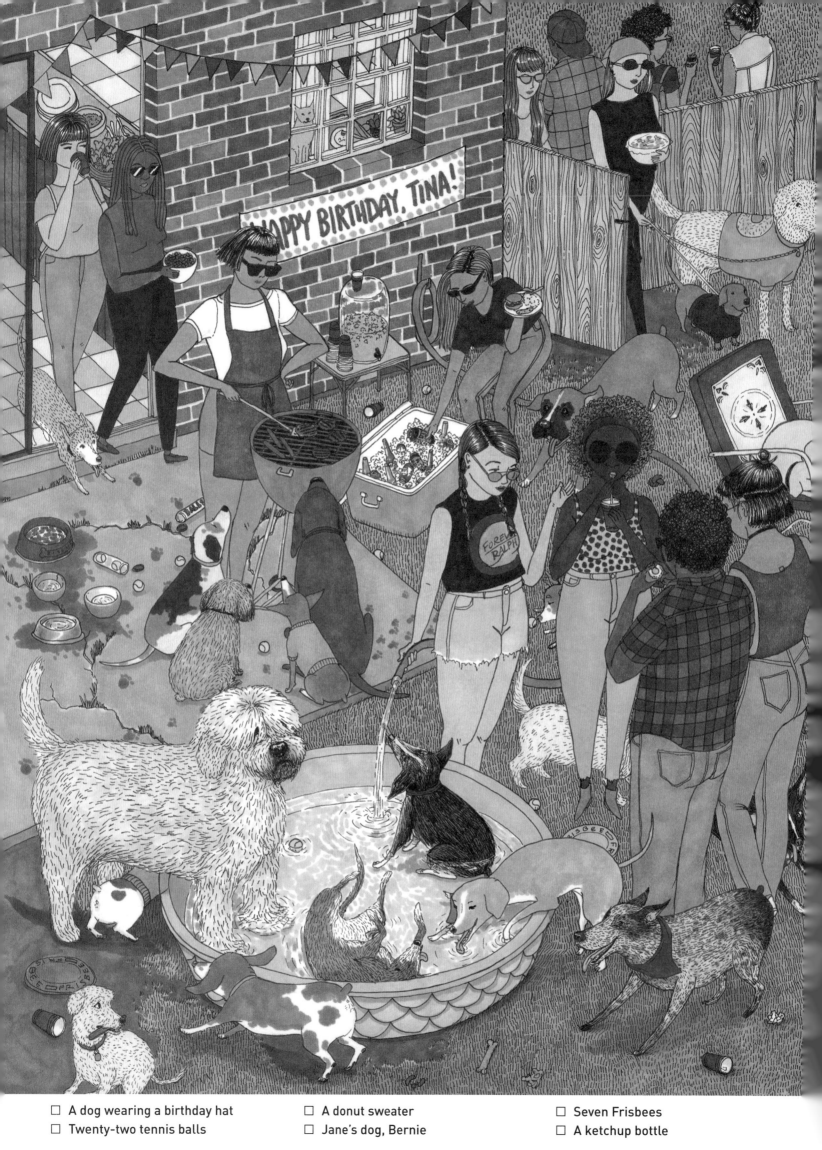

- [] A dog wearing a birthday hat
- [] Twenty-two tennis balls
- [] A donut sweater
- [] Jane's dog, Bernie
- [] Seven Frisbees
- [] A ketchup bottle

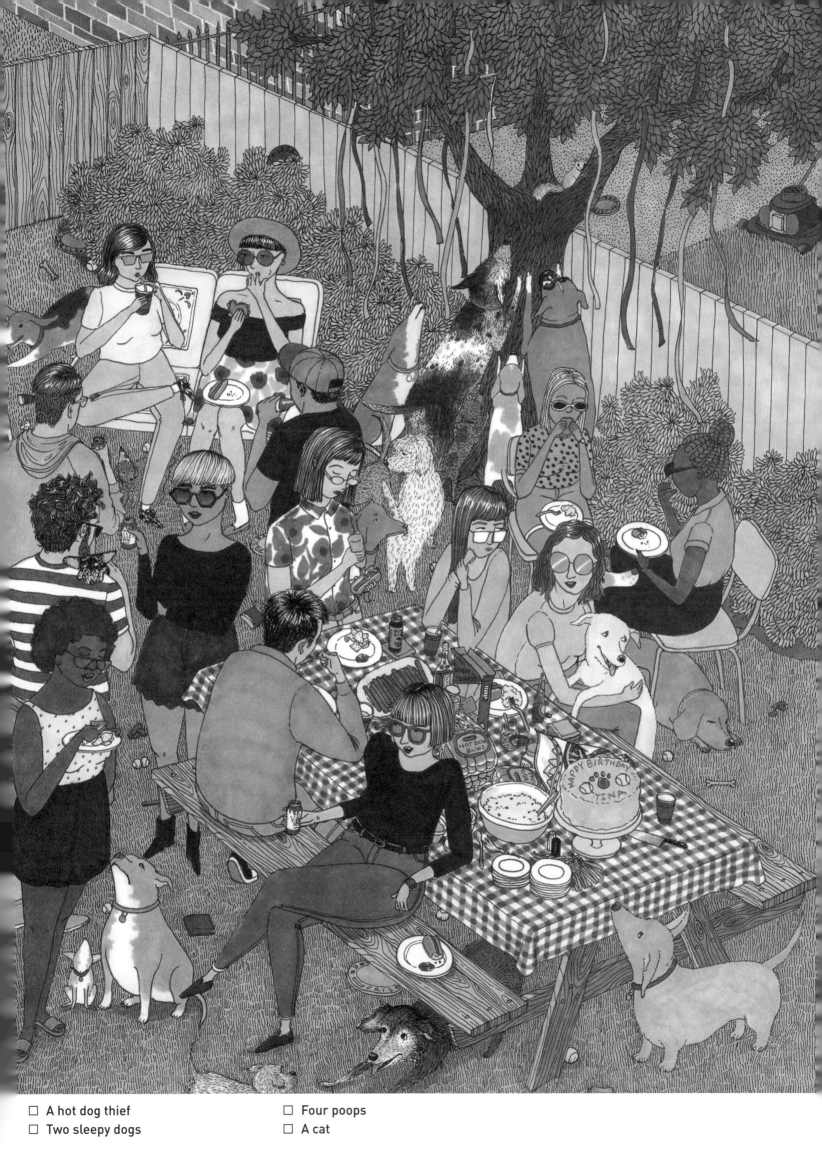

☐ A hot dog thief
☐ Two sleepy dogs
☐ Four poops
☐ A cat

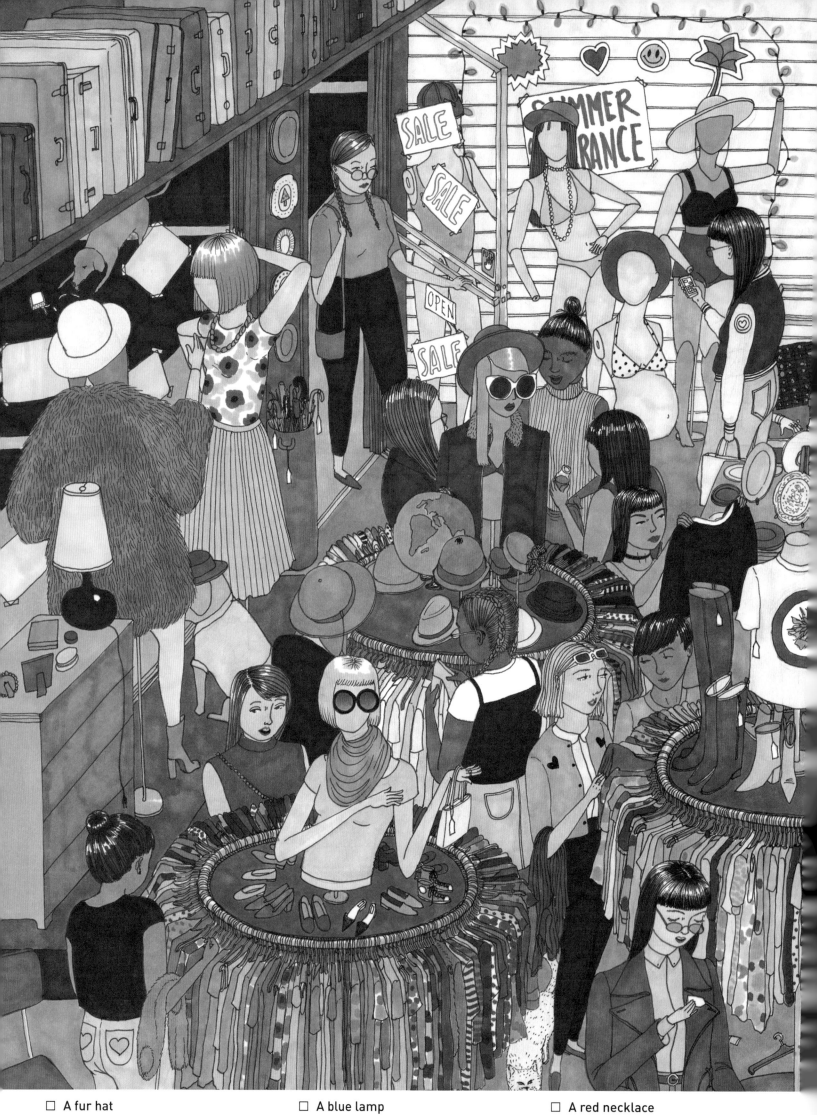

☐ A fur hat
☐ Seven hearts

☐ A blue lamp
☐ Three dogs

☐ A red necklace
☐ Three spiders

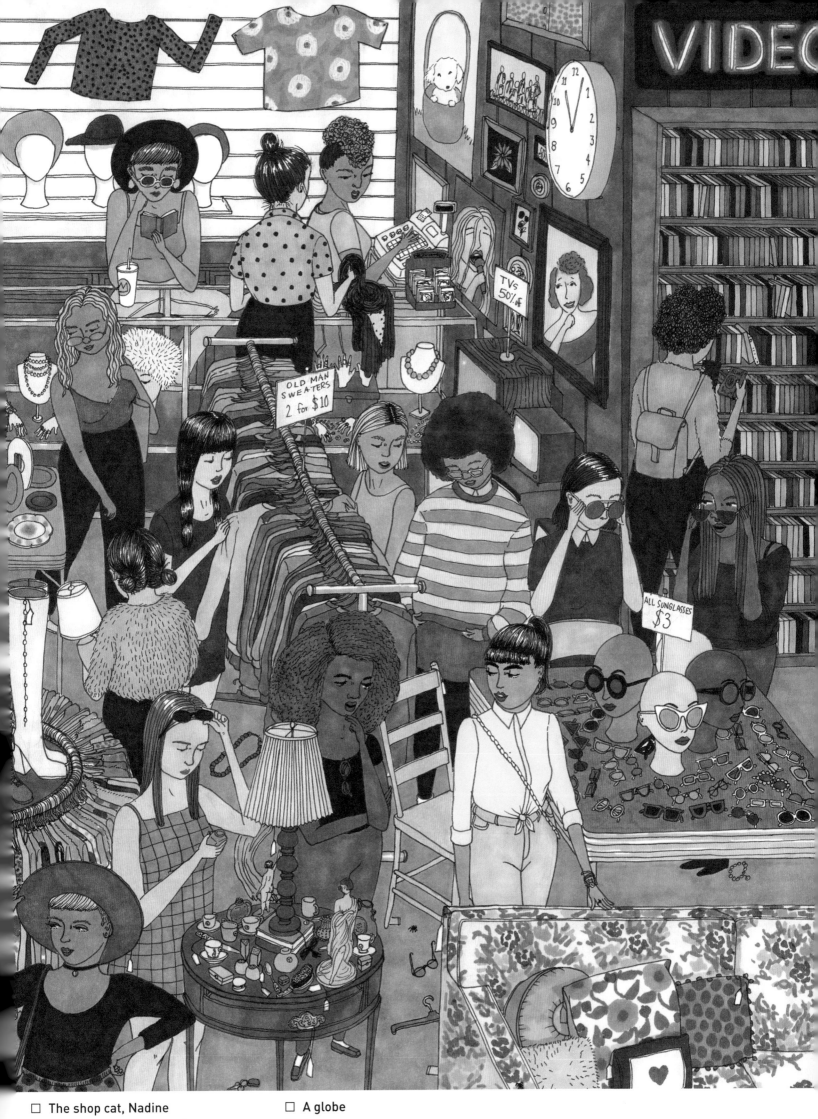

☐ The shop cat, Nadine
☐ An antique Christmas plate
☐ A globe
☐ A spoon

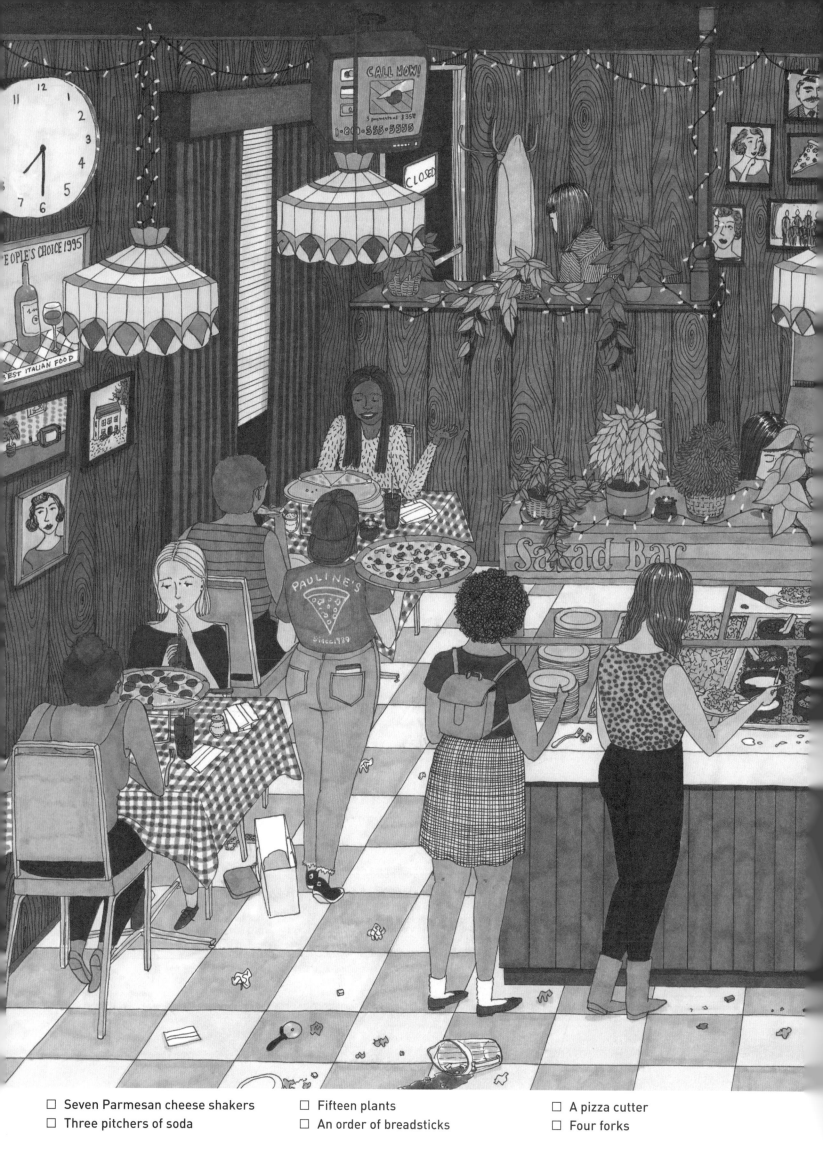

☐ Seven Parmesan cheese shakers
☐ Three pitchers of soda
☐ Fifteen plants
☐ An order of breadsticks
☐ A pizza cutter
☐ Four forks

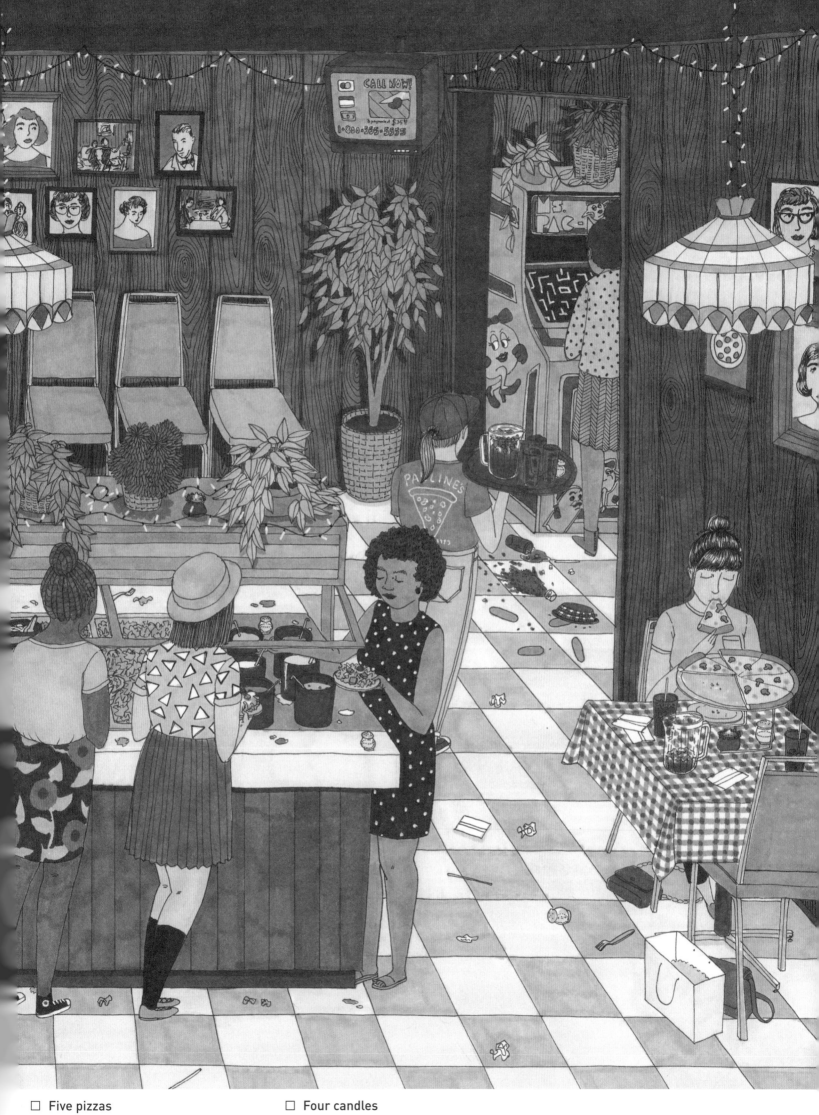

☐ Five pizzas

☐ Nine red cups

☐ Four candles

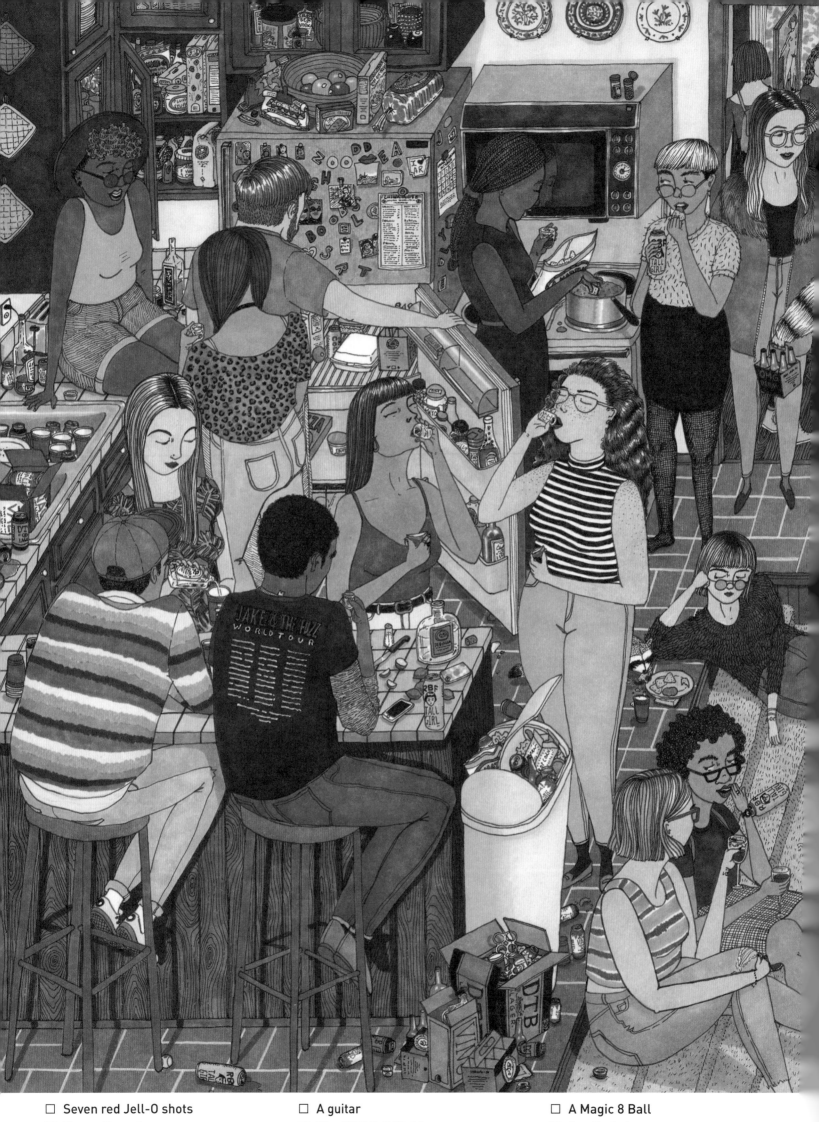

☐ Seven red Jell-O shots ☐ A guitar ☐ A Magic 8 Ball

☐ Owen, the pet raccoon ☐ Five RBF Tall Girl beer cans ☐ A salt shaker

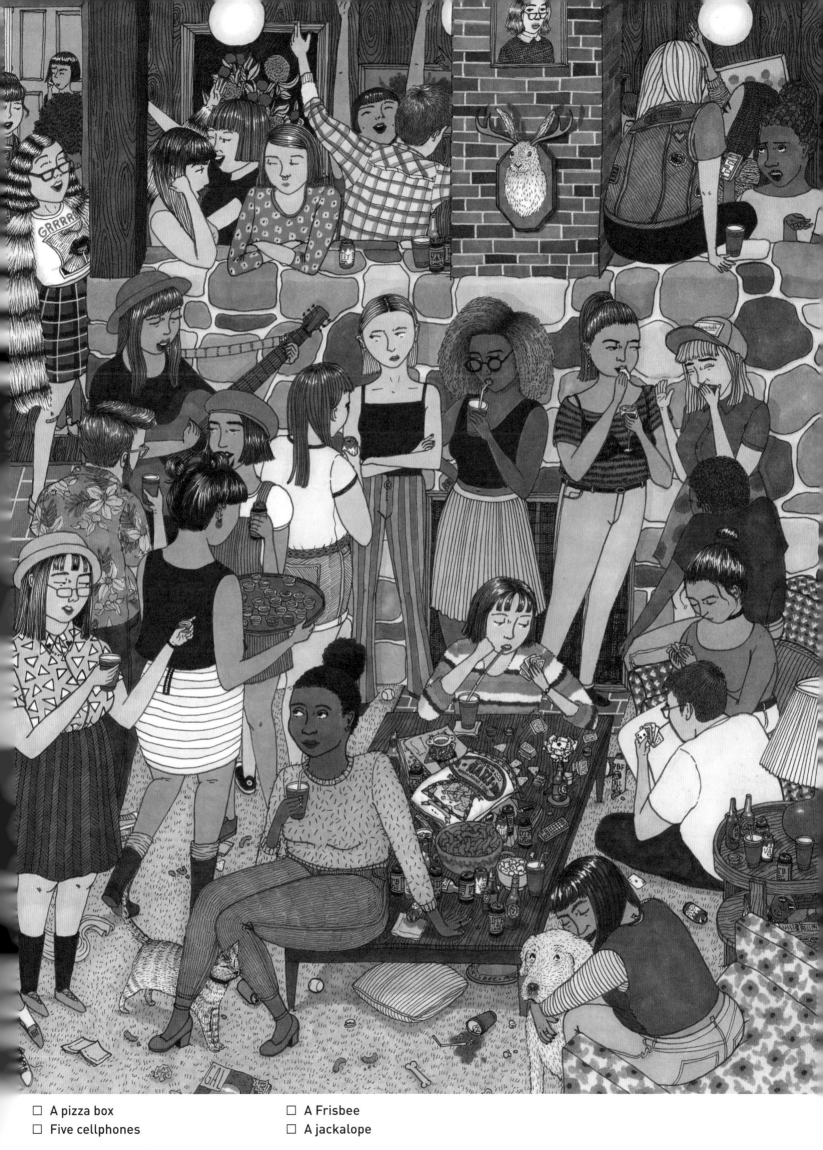

☐ A pizza box
☐ Five cellphones
☐ A Frisbee
☐ A jackalope

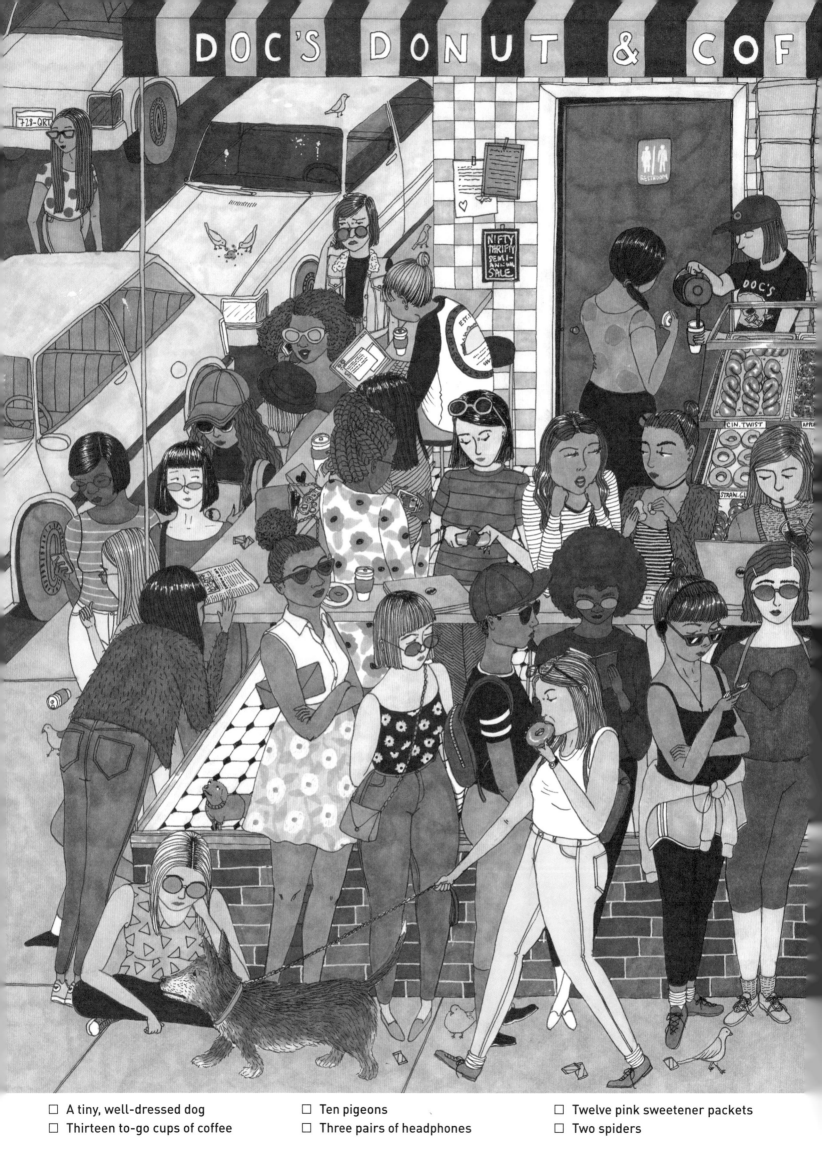

- ☐ A tiny, well-dressed dog
- ☐ Thirteen to-go cups of coffee
- ☐ Ten pigeons
- ☐ Three pairs of headphones
- ☐ Twelve pink sweetener packets
- ☐ Two spiders

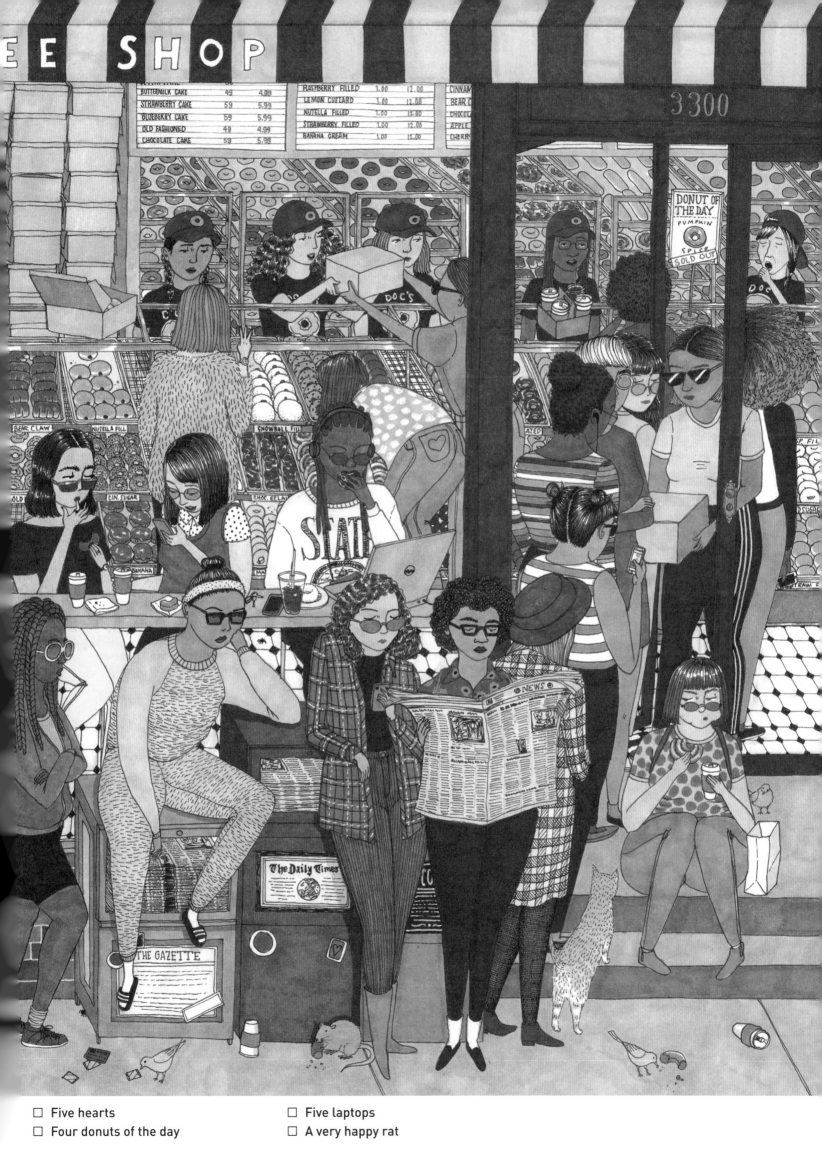

☐ Five hearts
☐ Four donuts of the day
☐ Five laptops
☐ A very happy rat

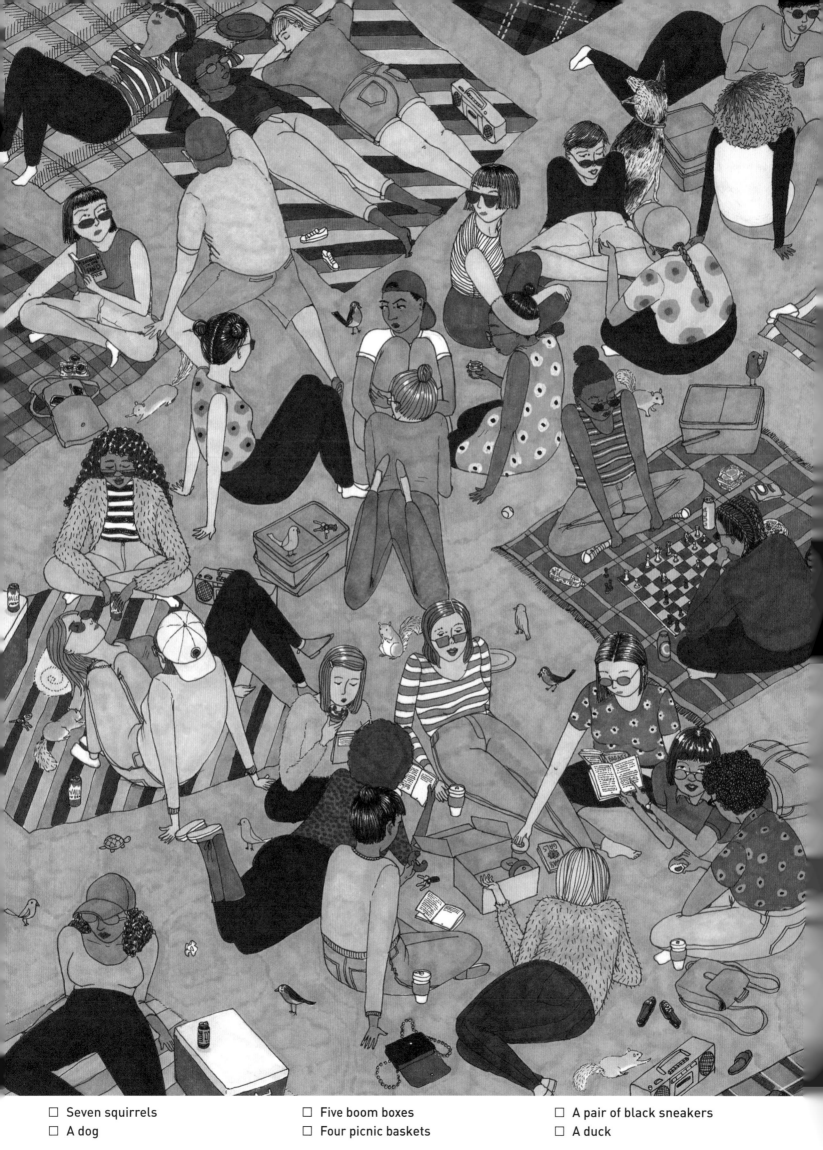

☐ Seven squirrels
☐ A dog
☐ Five boom boxes
☐ Four picnic baskets
☐ A pair of black sneakers
☐ A duck

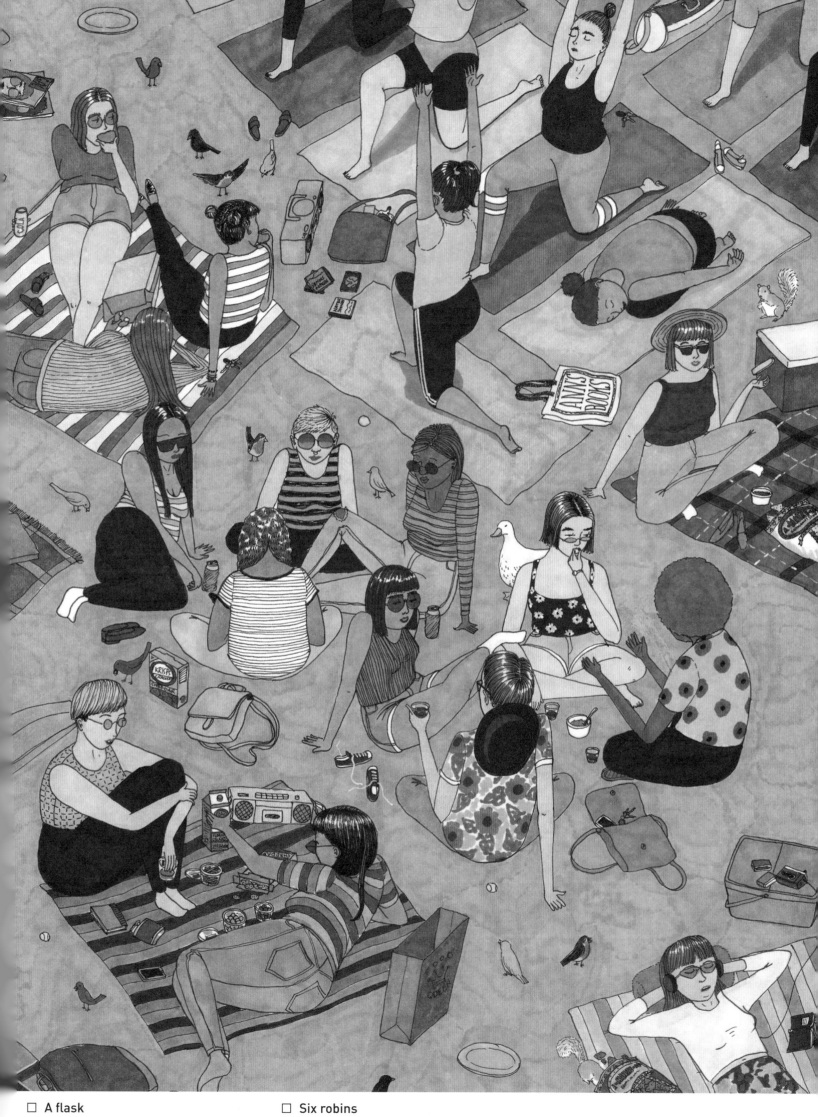

☐ A flask
☐ Six sets of keys
☐ Six robins
☐ A turtle

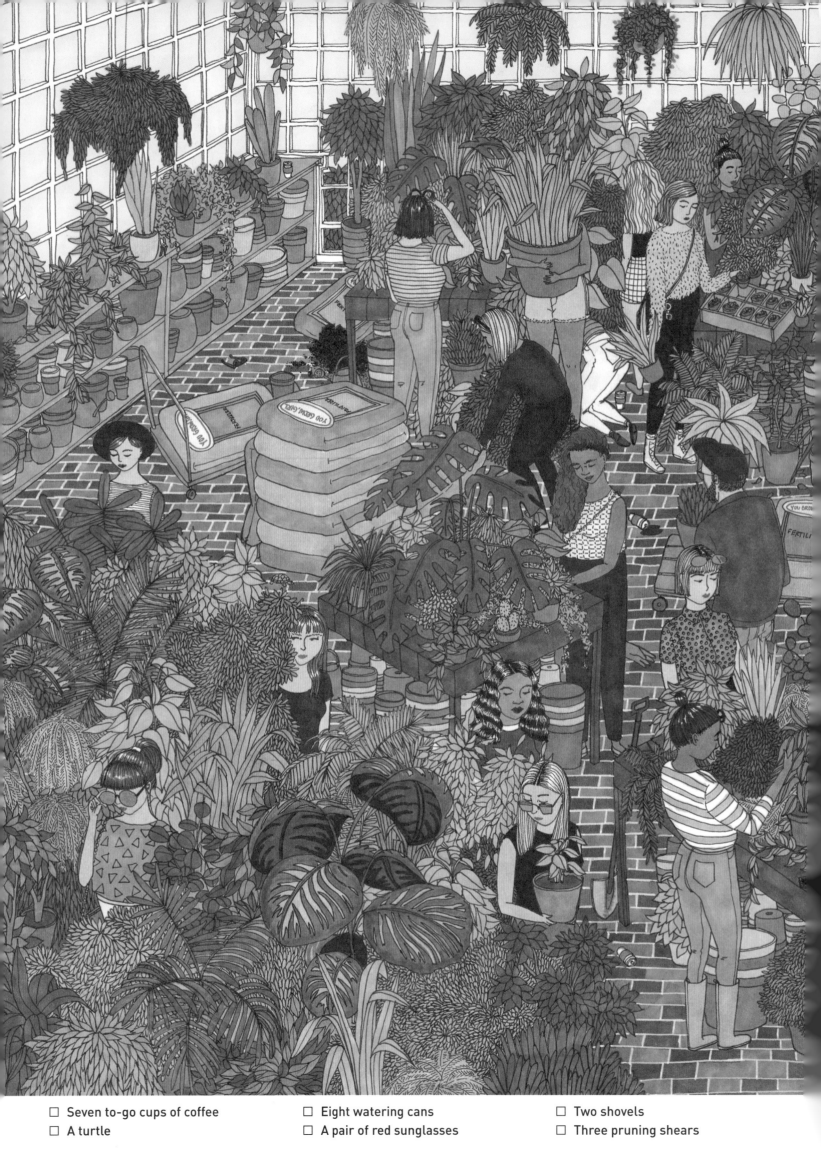

☐ Seven to-go cups of coffee ☐ Eight watering cans ☐ Two shovels
☐ A turtle ☐ A pair of red sunglasses ☐ Three pruning shears

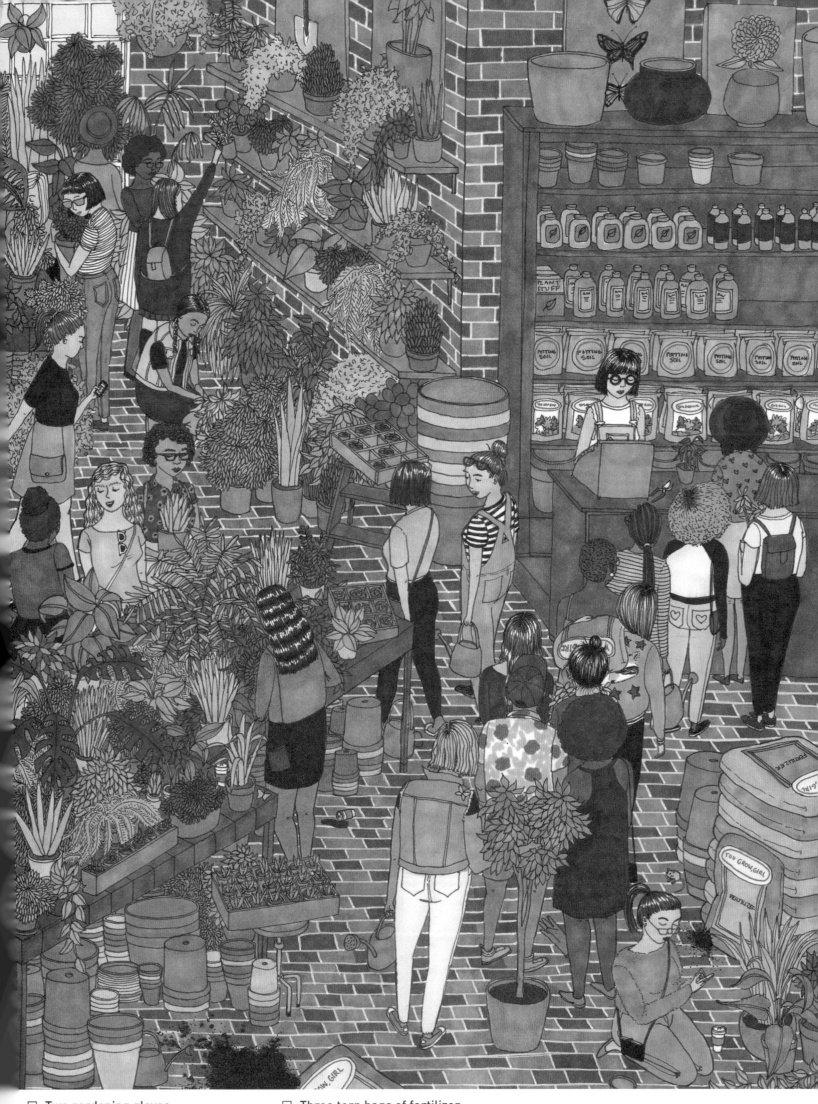

☐ Two gardening gloves
☐ Six butterflies
☐ Three torn bags of fertilizer
☐ A little gray mouse

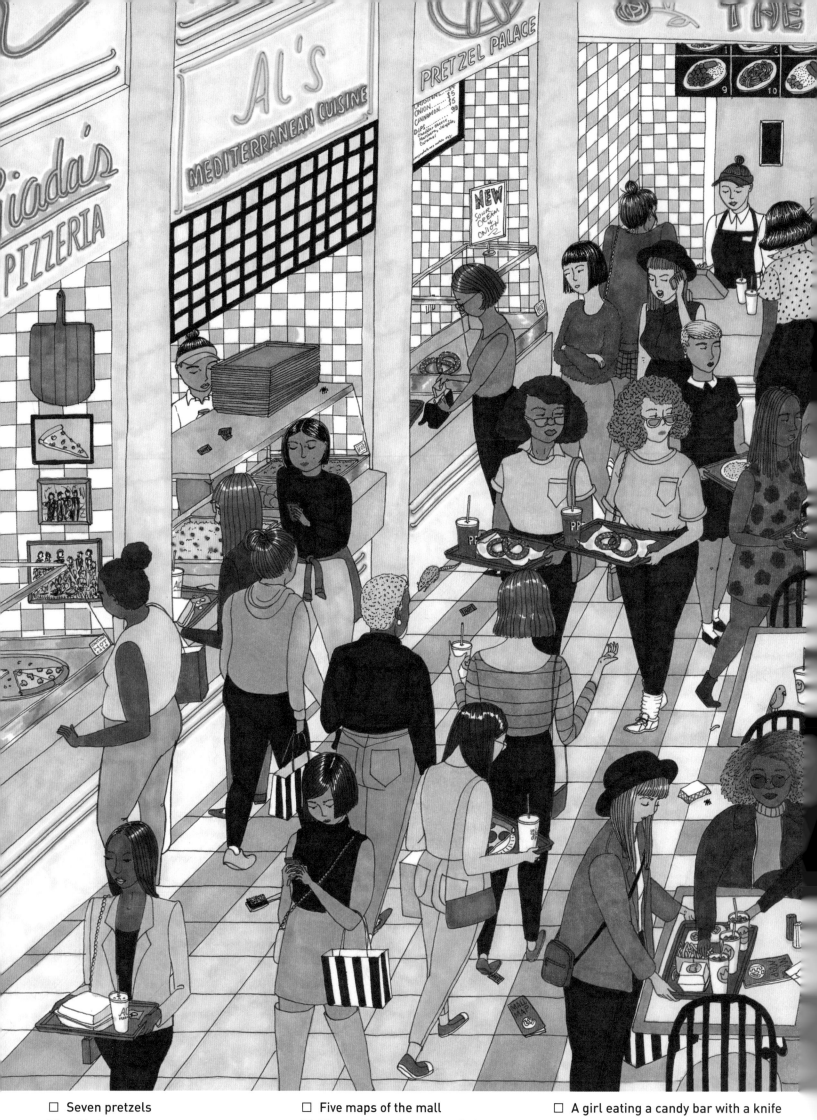

☐ Seven pretzels
☐ A bird

☐ Five maps of the mall
☐ Three slices of pepperoni pizza

☐ A girl eating a candy bar with a knife and fork

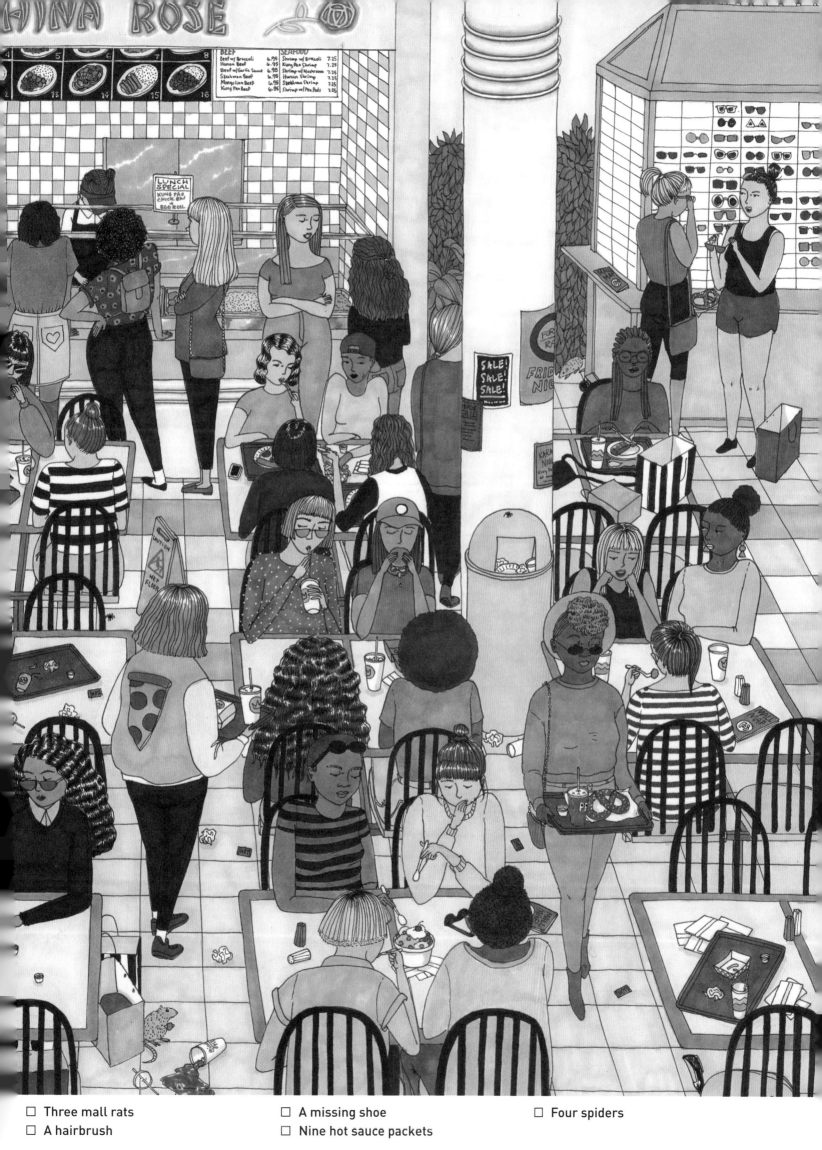

□ Three mall rats
□ A hairbrush
□ A missing shoe
□ Nine hot sauce packets
□ Four spiders

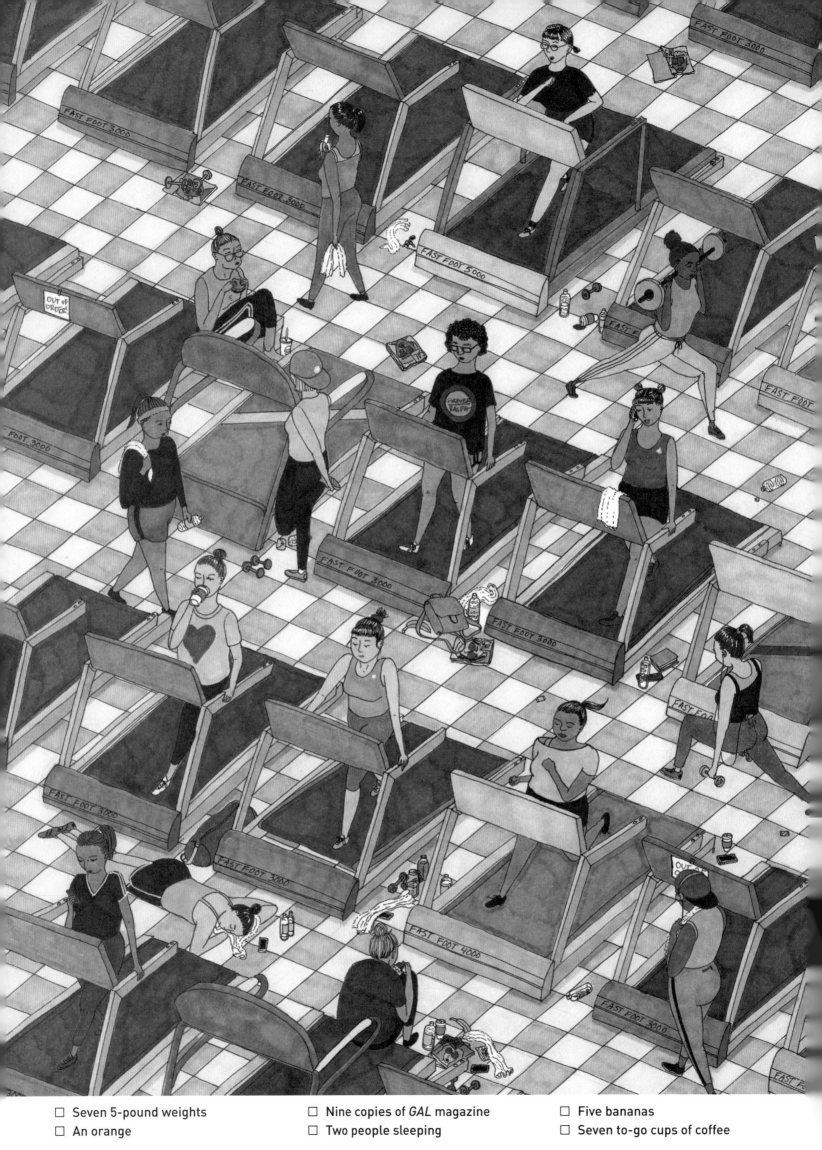

☐ Seven 5-pound weights ☐ Nine copies of *GAL* magazine ☐ Five bananas
☐ An orange ☐ Two people sleeping ☐ Seven to-go cups of coffee

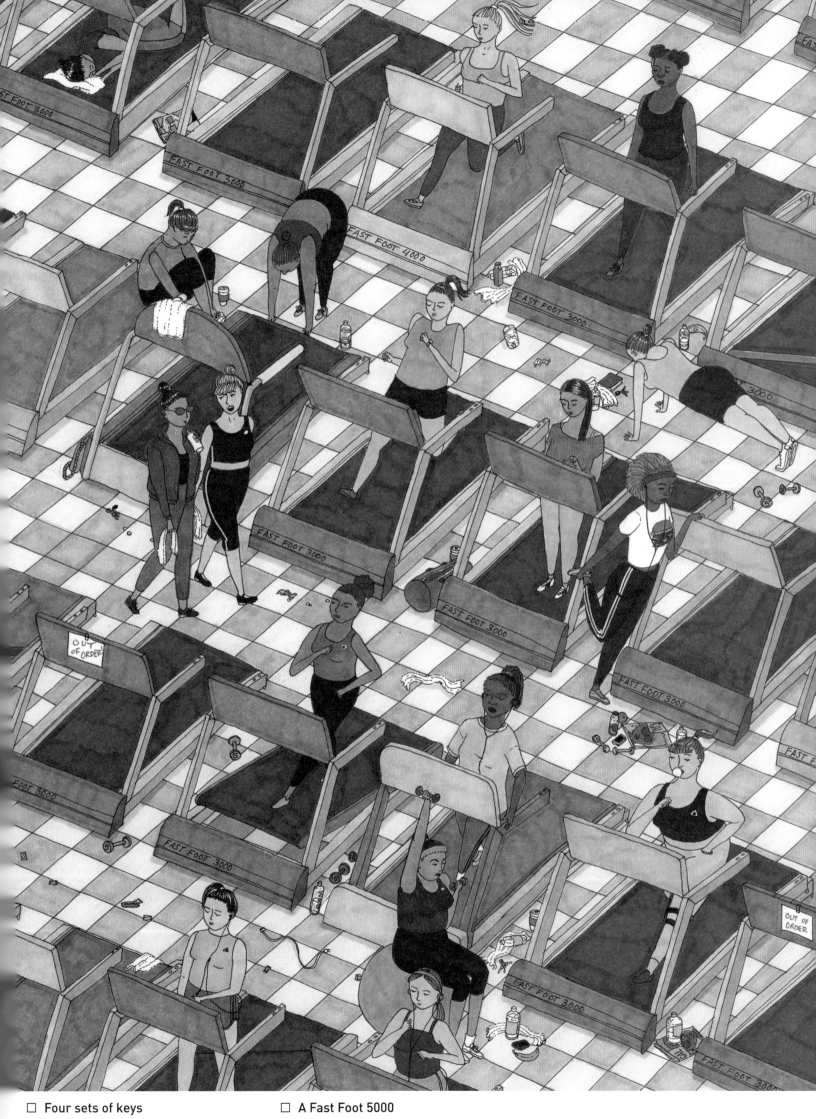

- ☐ Four sets of keys
- ☐ Nineteen towels
- ☐ A Fast Foot 5000
- ☐ Two cheeseburgers

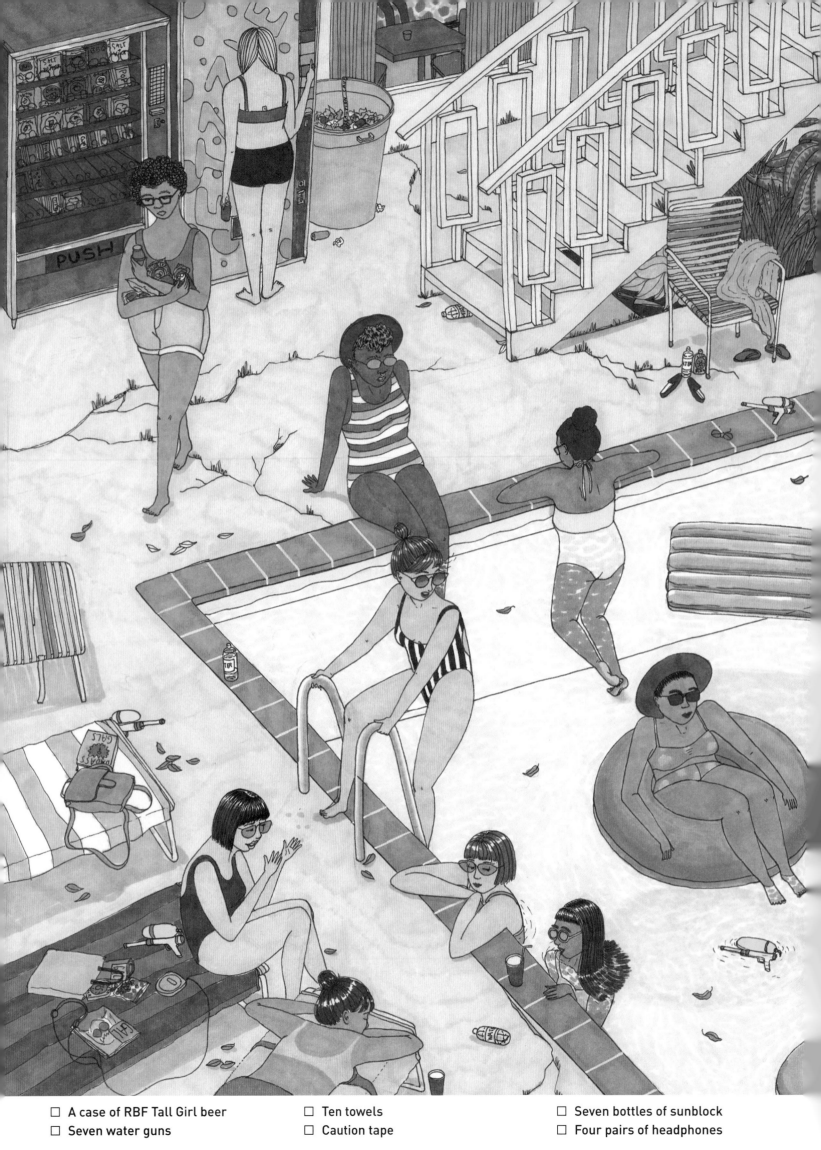

☐ A case of RBF Tall Girl beer ☐ Ten towels ☐ Seven bottles of sunblock
☐ Seven water guns ☐ Caution tape ☐ Four pairs of headphones

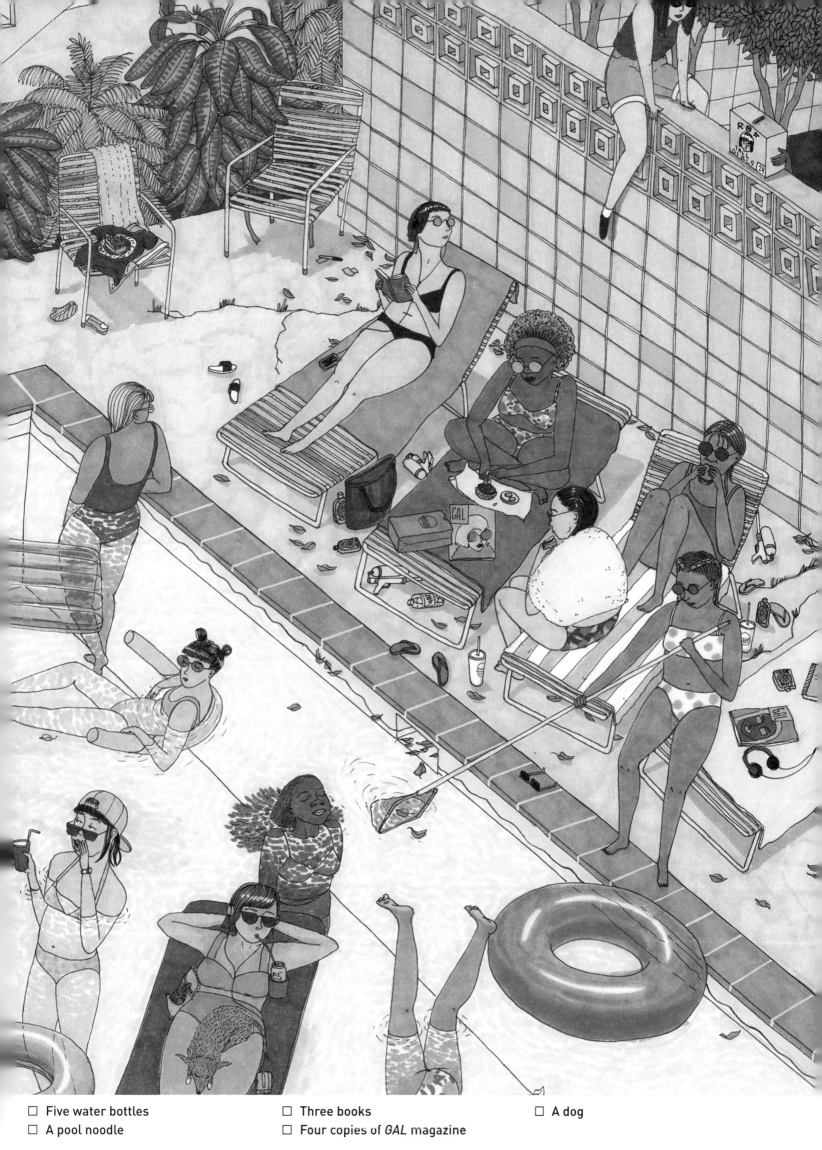

☐ Five water bottles
☐ A pool noodle
☐ Three books
☐ Four copies of *GAL* magazine
☐ A dog

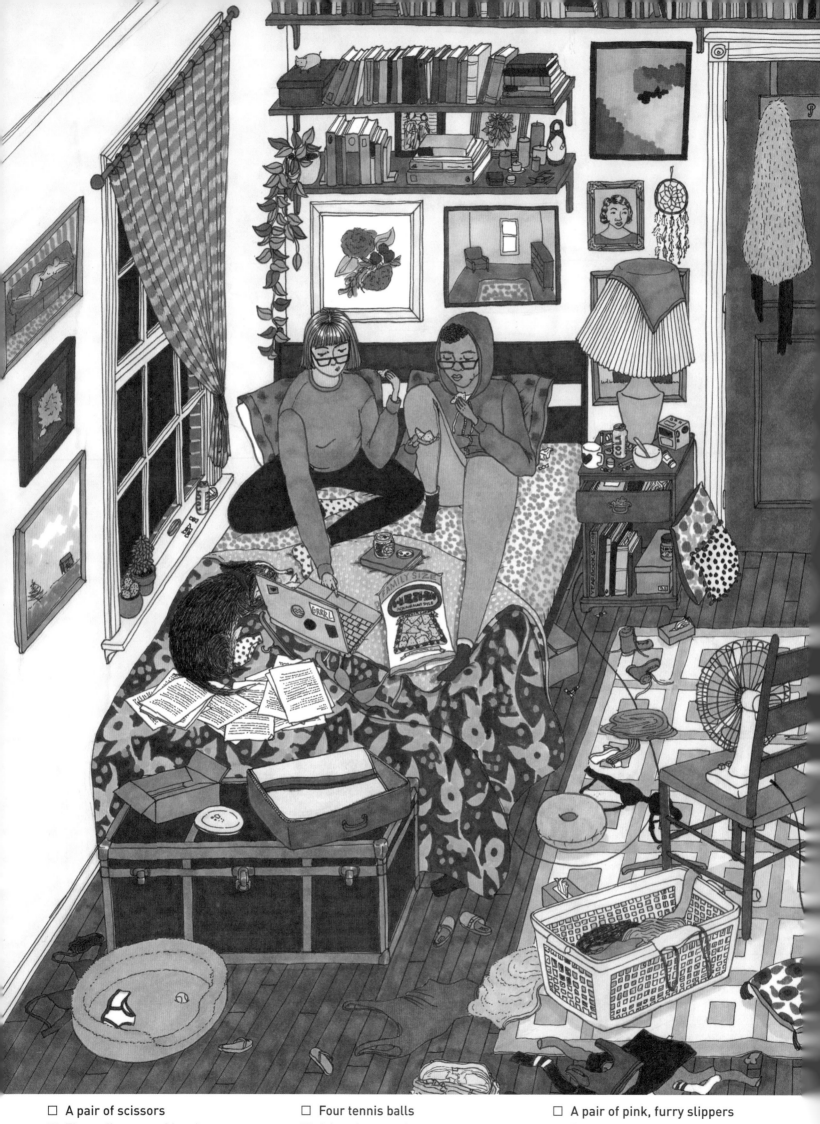

- ☐ A pair of scissors
- ☐ Three dirty cereal bowls
- ☐ Four tennis balls
- ☐ A jar of peanut butter
- ☐ A pair of pink, furry slippers
- ☐ Seven houseplants

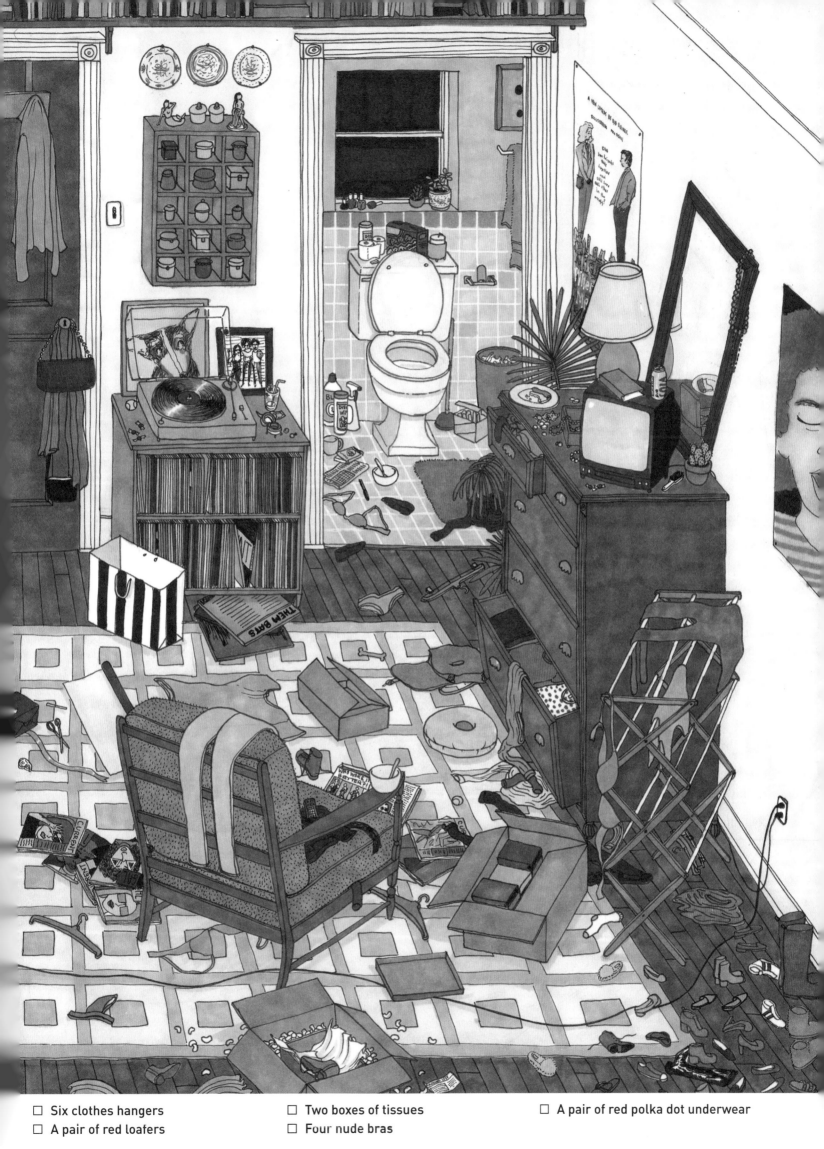

☐ Six clothes hangers

☐ A pair of red loafers

☐ Two boxes of tissues

☐ Four nude bras

☐ A pair of red polka dot underwear

"Oh, not much."

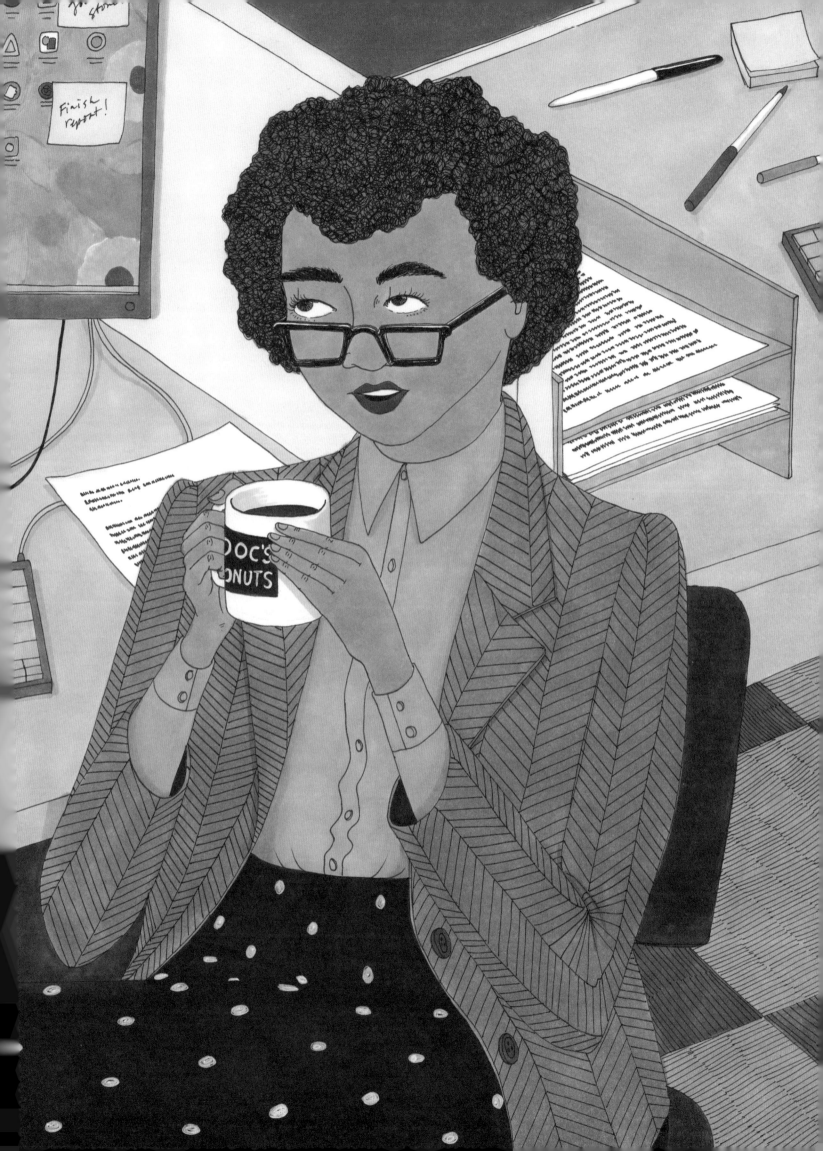

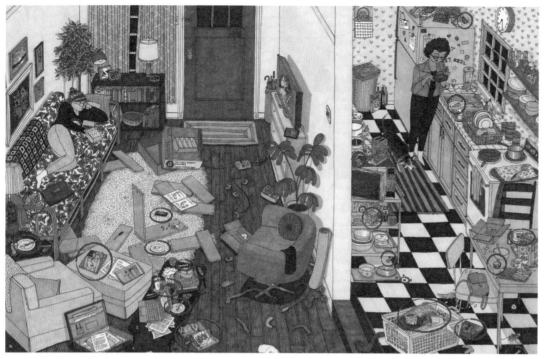
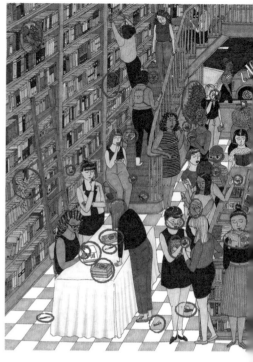
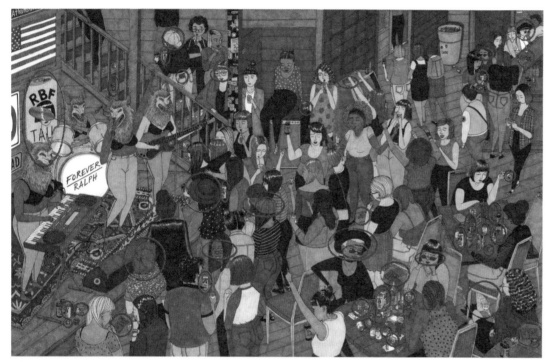
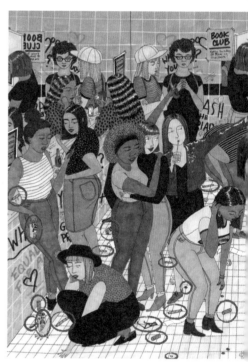
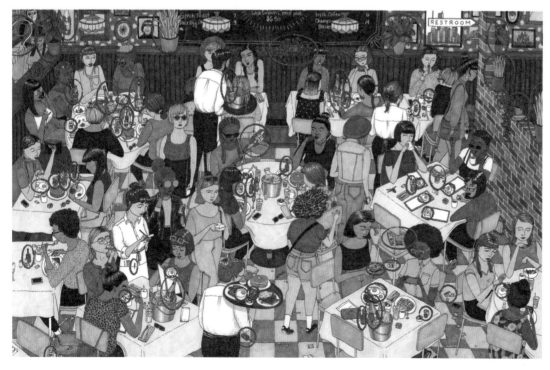
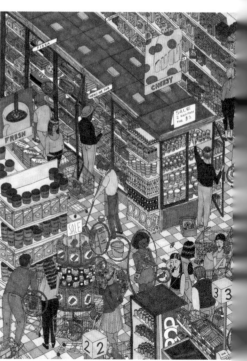

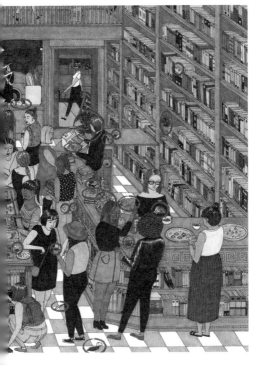
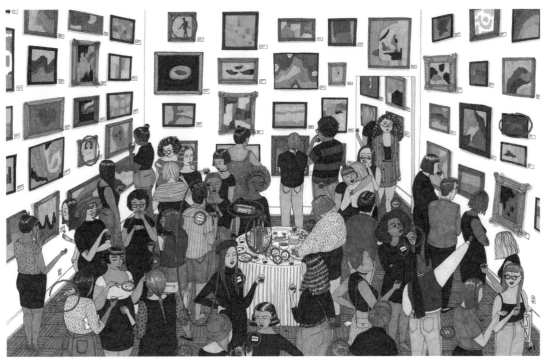
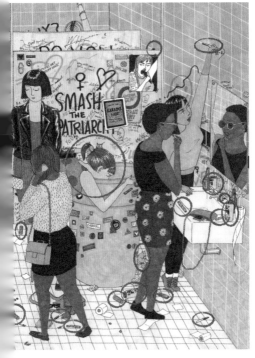
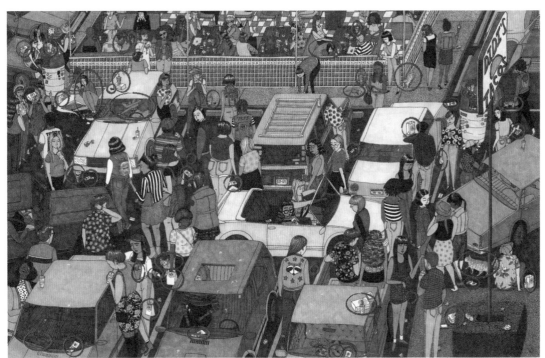
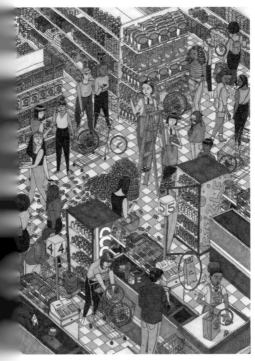
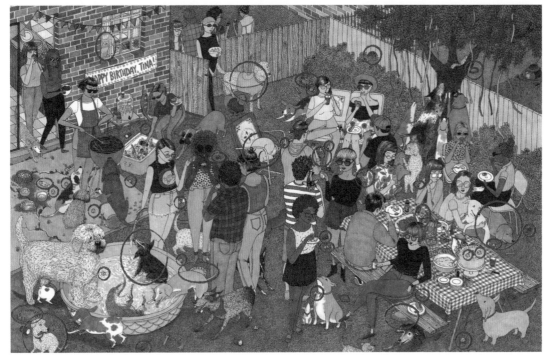

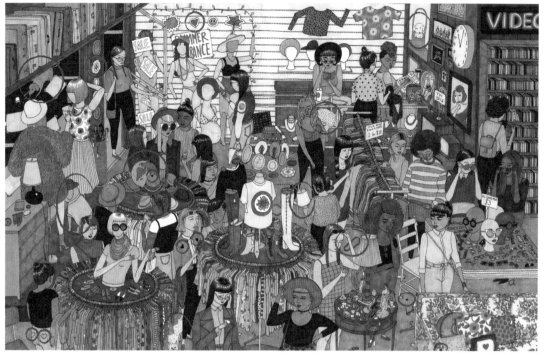
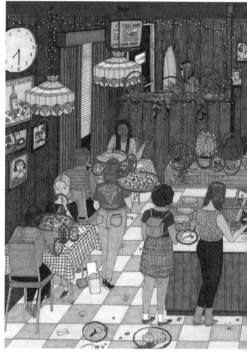
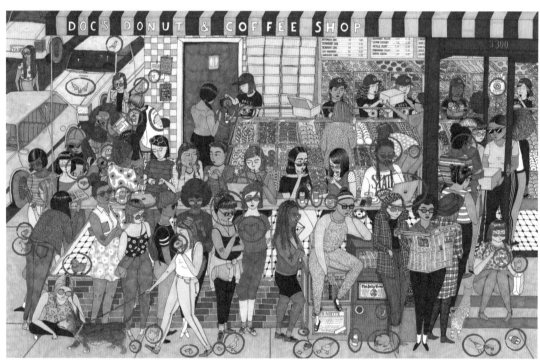
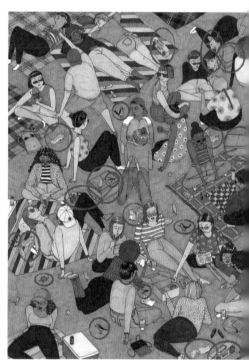
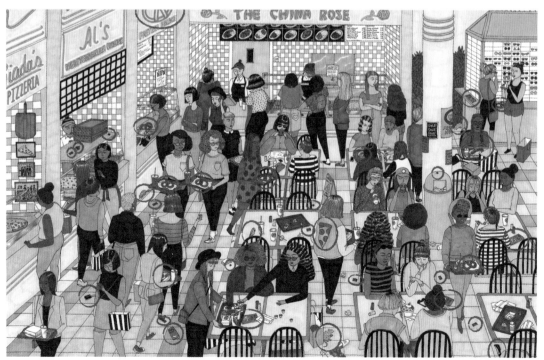
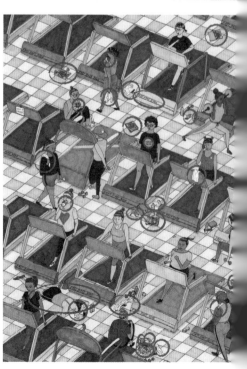

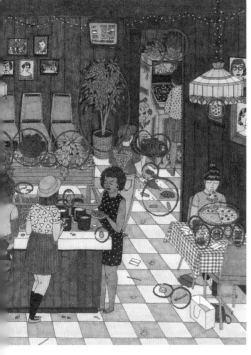
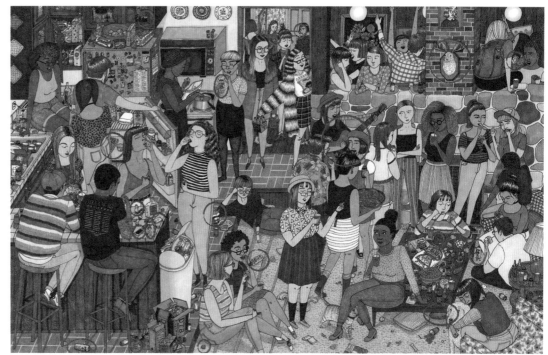
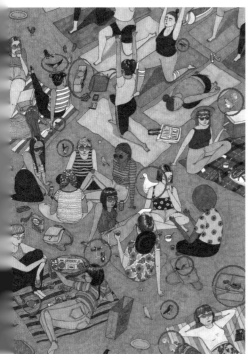
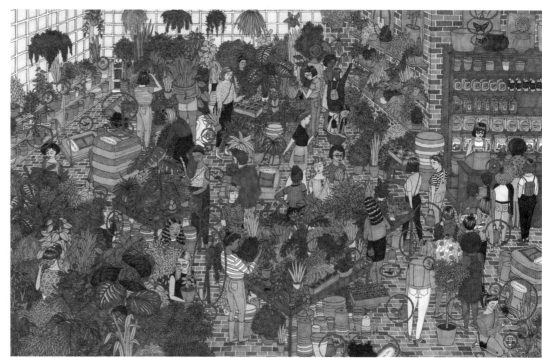
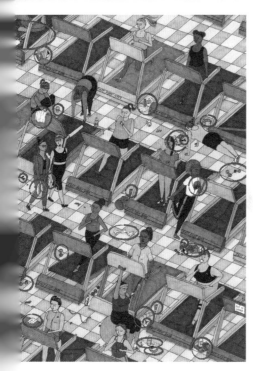
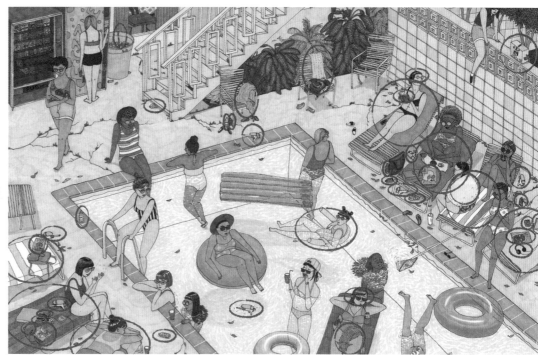

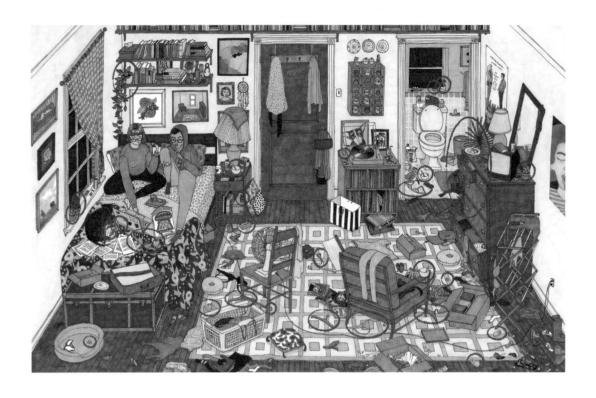

Library of Congress Cataloging-in-Publication Data available.

ISBN: 978-1-4521-6313-0

Manufactured in China

Design by Kayla Ferriera
Typeset in DIN and Blog Script

10 9 8 7

Chronicle Books LLC
680 Second Street
San Francisco, California 94107

www.chroniclebooks.com

Chronicle books and gifts are available at special quantity discounts to corporations, professional
associations, literacy programs, and other organizations. For details and discount information, please
contact our premiums department at corporatesales@chroniclebooks.com or at 1-800-759-0190.